Walking Harlem

Walking Harlem

The Ultimate Guide to the Cultural Capital of Black America

Karen F. Taborn

RUTGERS UNIVERSITY PRESS

New Brunswick, Camden, and Newark, New Jersey, and London

Library of Congress Cataloging-in-Publication Data
Names: Taborn, Karen Faye, author.
Title: Walking Harlem : the ultimate guide to the cultural capital of
Black America / Karen Faye Taborn.
Description: New Brunswick, New Jersey : Rutgers University Press, 2018. |
Includes bibliographical references and index.
Identifiers: LCCN 2017033817| ISBN 9780813594576 (pbk. : alk. paper) |
ISBN 9780813594606 (Web PDF) | ISBN 9780813594583 (epub) |
ISBN 9780813594590 (mobi)
Subjects: LCSH: Harlem (New York, N.Y.)—Tours. | New York (N.Y.)—Tours.
Classification: LCC F128.68.H3 T33 2017 | DDC 917.47/104—dc23
LC record available at https://lccn.loc.gov/2017033817

A British Cataloging-in-Publication record for this book is available
from the British Library.

∞ The paper used in this publication meets the requirements of the American
National Standard for Information Sciences—Permanence of Paper for
Printed Library Materials, ANSI Z39.48–1992.

www.rutgersuniversitypress.org

Manufactured in the United States of America

To my parents,
Albert and Jeannette (Tyler) Taborn,
who taught me to appreciate
my culture and history

Contents

PART I: TOURS

PART II: HARLEM: PEOPLE, PLACES, AND MOVEMENTS

About This Book

Walking Harlem traces the musical, literary, visual arts, dance, and socio-political developments in Harlem from around 1919 to the present with a focus on the 1920s–1930s Harlem Renaissance. The book draws from numerous sources including historical and out-of-print texts, newspapers, record liner notes, and film to focus on the cultural, arts, and political developments of African Americans in Harlem, and it links this information to five self-guided walking tours. The author's background as an ethnomusicologist is evident in a focus on music venues that have often been overlooked in previous researches.

Tours are based on proximity of sites to one another along each tour route; however, key themes may be identified in each tour. Tour 1 includes the Schomburg Center, Striver's Row, key literati locales, Abyssinian Baptist and Mother AME (African Methodist Episcopal) Zion Churches, the (original) Cotton Club, and the Savoy Ballroom. Tour 2 also begins at the Schomburg Center and features community art murals funded by the Works Progress Administration and small and large music entertainment venues and speakeasies. Tour 3 includes 125th Street,

the Apollo Theater, the Mount Morris District, Minton's Playhouse jazz club, the former homes of Langston Hughes and Maya Angelou, and the original site for Temple No. 7 (Malcolm X's religious and spiritual home from the mid-1950s to the mid-1960s). Tour 4 covers the City College of New York and the (Alexander) Hamilton Heights district. Tour 5 covers the neighborhood of Sugar Hill's apartment buildings and nightclubs and pre–Harlem Renaissance sites (Morris-Jumel Mansion and Jumel Terrace). The tour ends at the Malcolm X and Dr. Betty Shabazz Memorial and Educational Center (the former Audubon Ballroom) in Washington Heights. The estimated times per tour are included at the beginning of each tour, and recommended restaurants and eateries are included in each tour for walkers to stop and take a break along the tour routes if desired.

This tour guidebook and its accompanying maps provide a concise history with background on the most significant developments of the Harlem Renaissance era and beyond with the places and people associated with them. Those who are interested in reading a more in-depth background on social developments or important Harlem personalities can refer to part 2 of the book, enabling you to greater familiarize yourself with the social-political-cultural history of Harlem.

In addition to reading and following the tours in this book, I encourage you to expand on your knowledge and appreciation of Harlem's vast and rich culture on your own

by revisiting sites that remain in operation today and those that have sprung up since the Renaissance era but reflect back on Harlem's rich past as well as celebrate its present and future.

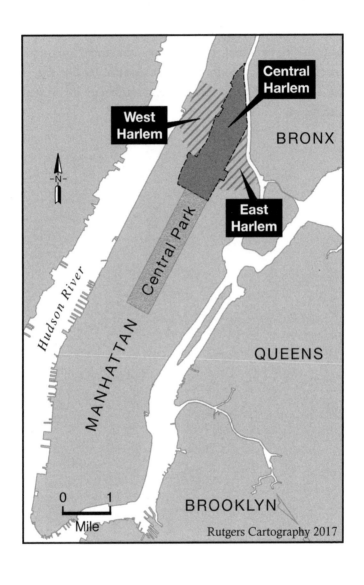

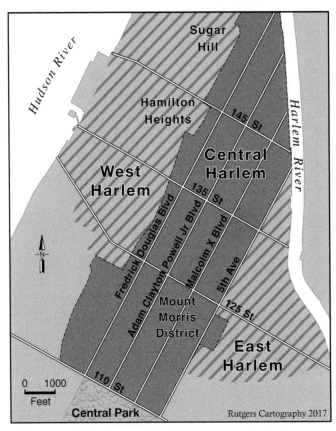

Harlem is roughly located north of 110th Street (Central Park North), south and west of the Harlem River, and east of the Hudson River. Subsections of Harlem include Spanish Harlem, to the east of Fifth Avenue, spiraling outward from 116th Street, and West Harlem, including Hamilton Heights and Sugar Hill.

Walking Harlem

Introduction

During the late 1800s, real estate brokers had geared Harlem property to be set aside as an upper-class white residential area. Wall Street stockbrokers and other whites who could afford it were to be lured uptown to reside with the whites who lived there at the time. Harlem was mostly made up of European immigrants. The southeast corner of Harlem was Italian, the central-south section was largely Russian Jew, and the Germans and Irish were in the center and the north. There were also sections made up of second- and third-generation American whites. A relatively small group of Blacks also resided in Harlem at the time, living in scattered pockets.

The majority of Blacks were living in a crowded ghetto on the west side of Manhattan in the Columbus Circle area known as San Juan Hill. Some were able to find apartments in the west twenties and thirties.[1] In any case, Harlem in the late 1800s was New York City's first suburb. It was prime real estate and seemingly the perfect location to develop an upper-class white residential enclave. The expected real estate boom failed. Real estate brokers overestimated the interests that whites had in Harlem property and found

themselves with an excessive amount of real estate on their hands. Brokers began to panic.

In 1901, in desperation to earn back money invested in the would-be boom, Philip Payton, an enterprising Black real estate broker, proposed acting as a liaison to Black families who were willing to pay even higher rents than the prospective white tenants. Harlem property interests soon attracted the crème de la crème of New York's Black business leaders. They organized themselves into the Afro-American Realty Company that Payton founded in 1904. National support for the company came from Black business leaders such as Booker T. Washington, who was on close personal and business terms with all the company's board member.[2]

The first bold Blacks to move into exclusively white areas in Harlem were not welcome. There were a number of organized efforts to block their inflow, including the Hudson Realty Company, the West Side Improvement Corporation, the West Harlem Property Owners' Association, the Save Harlem Committee, the Committee of Thirty, and the Harlem Property Owners' Improvement Corporation.[3] However, after much perseverance, the area between 133rd and 134th Streets and between Lenox and Seventh Avenues began to open up. Around the same time, the first migration of southern Blacks, attempting to escape Jim Crow and looking for better working and living conditions, made their way to New York City. Between 1910 and

1930, the Black population of New York City grew from 91,709 to 327,796.[4]

From the outset, two important developments took place—one, the grand scale in which political leadership emerged, and the other, the development of the arts and the emergence of the greatest concentration of Black intellectuals to be realized in the United States before the 1920s and 1930s Harlem Renaissance. Through the years, there has been constant interaction between the political and artistic movements in Harlem, with both movements being driven, to a great extent, by the omnipresent theme of overcoming racism.

By 1920, Harlem had a substantial Black presence, and the way had been paved for a Harlem Renaissance—a home for writers, political and social activists, musicians, and visual artists who befriended one another, lived, worked, played, competed with one another, and in some cases, fought against one another. During the height of Jim Crowism and racial segregation in the United States and in the midst of the sexual expressiveness of the Roaring Twenties, the Harlem community often demonstrated a liberalism beyond American social norms like no other locale. Above all, the Harlem Renaissance was a special place and time when Black Americans challenged themselves to find a voice of their own. In so doing, Harlemites created one of the most vibrant and exhilarating cultures known anywhere before or since its time.

By the mid 1940s, drastic changes were taking place in Harlem. Most of the white- and black-owned clubs had moved downtown, and 52nd Street became the main street of jazz. Locating jazz clubs on one street that was easily accessible to white jazz fans, who had more money to spend than Blacks, was the motive. Unfortunately, the effect that this had on Harlem and the money that flowed into it was devastating, especially in comparison to the swing-band period, when thousands of Blacks were employed in Harlem clubs as entertainers, waiters, cooks, coatroom girls, and doormen.[5]

Since the 1940s, the economic, political, and sociocultural changes in Harlem have been vast and complex. Following the Harlem Renaissance of the 1920s–1930s, Harlem became known as an infamous ghetto, and more recently, Harlem has controversially become known as Manhattan's current neighborhood for gentrification. Regardless of changing demographics, it is imperative to remember and celebrate Harlem's rich history.

Part I

Tours

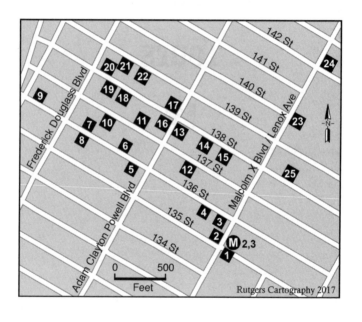

Rutgers Cartography 2017

Tour 1

Central Harlem: North

Estimated duration: 2 hours

1. Subway Mosaics by Willie Birch
2. Schomburg Center for Research in Black Culture
3. Madame C. J. Walker Residence and the Dark Tower Salon
4. Tempo Club
5. New York Urban League
6. Office of the Brotherhood of Sleeping Car Porters
7. "Niggerati Manor"
8. Harlem Art Workshop, Location No. 2
9. Uptown Art Laboratory and Harlem Artists Guild
10. John Henrik Clarke Residence
11. Barbara Ann Teer Residence
12. Mother AME Zion Church
13. Renaissance Casino and Ballroom
14. Abyssinian Baptist Church
15. Liberty Hall / Garvey Site
16. Original Red Rooster
17. Striver's Row
18. William and Isabelle Spiller Residence
19. Eubie Blake Residence
20. Harry C. Pace Residence
21. W. C. Handy Residence
22. Fletcher Henderson Residence
23. Savoy Ballroom
24. Cotton Club
25. St. Mark's Church and Hall / Marcus Garvey Site

➤ Take the 2 or 3 subway to the 135th Street station.

Tour 1, Site 1
Subway Mosaics by Willie Birch

135th Street subway station

Before exiting the subway turnstile gate, see the mosaic artwork on the uptown and downtown sides of the 2 and 3 train platforms, the series of five mosaics titled *Harlem Timeline* by New Orleans native Willie Birch. In the 1990s, New York City commissioned African American artists to create mosaics installed along the Lenox Avenue / Malcolm X Boulevard subway line in Harlem. The art celebrates Harlem's rich history and famous Harlemites.

➤ Exit the subway to find Site 2, on the northwest corner of the intersection of 135th Street and Malcolm X Boulevard (Lenox Avenue).

Tour 1, Site 2
Schomburg Center for Research in Black Culture

Northwest corner of West 135th Street and Malcolm X Boulevard

The Schomburg Center is named after Arthur Schomburg, a Black Puerto Rican who collected a mass array of over ten thousand Black intellectual and artistic creations

FIGURE 1. Langston Hughes burial site, "Rivers" cosmogram *(Mosaic created by Houston Conwill, Estella Conwill Majozo, and Joseph DePace at the Schomburg Center; courtesy of the Schomburg Center for Research in Black Culture, photo by K. Taborn, 2017)*

in response to a childhood teacher telling him that Blacks were devoid of history and culture. The New York Public Library purchased Schomburg's massive collection in 1926 and continued to build on the collection thereafter. The Schomburg Center is rare in Harlem, having played a continuously significant role in the community's rich culture and history from the 1920s until today. Today it is a leading research center in the United States on Black culture and history, with ongoing lectures, exhibitions, and cultural presentations.

When writer Langston Hughes (a frequent visitor to the center) died in 1967, his cremated ashes were buried

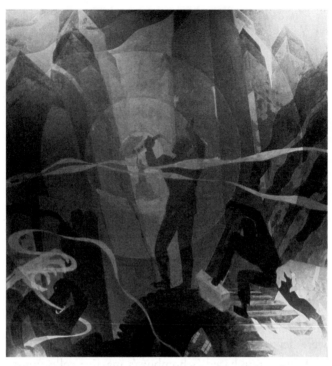

FIGURE 2. Aaron Douglas's mural "Song of the Towers" from the series *Aspects of Negro Life (Courtesy of the New York Public Library)*

under the cosmogram titled "Rivers" in the atrium floor of the Schomburg Center. Inspired by Hughes's poem "The Negro Speaks of Rivers," the cosmogram is a collaboration between sculptor Houston Conwill, writer Estella Conwill Majozo, and architect Joseph DePace that links the geographical and mythical life journeys of Blacks in Africa and North America. Hughes's burial at the Schomburg Center

conveys the significance that it held for him and many African Americans, as a bedrock of African American identity, culture, and history. You may visit the Langston Hughes cosmogram just beyond the lobby in the atrium of the center.

Harlem painter Aaron Douglas, often referred to as "the father of the Harlem Arts Movement," contributed a panel of four murals, titled *Aspects of Negro Life*, to the museum in 1934, funded by President Franklin D. Roosevelt's Works Progress Administration. The murals depict African Americans' journey from freedom in Africa, through enslavement in the United States, to the Reconstruction period. Ask at the information counter to see the murals through the glass windows of the Latimer/Edison Gallery.

The Schomburg Center is open to the public Tuesday through Thursday, 12 p.m. to 8 p.m.; Friday and Saturday, 10 a.m. to 6 p.m.; closed Sunday and Monday.

To read more about Aaron Douglas and the 1930s Harlem Arts Movement, see page 158.

► Walk northward to 136th Street and turn left on the south side of the street to find Site 3.

Tour 1, Site 3

Madame C. J. Walker Residence
and the Dark Tower Salon

108–110 West 136th Street (south side of street)

In the early twentieth century, Madame C. J. Walker be-
came the wealthiest self-made millionaire in the United
States by developing and marketing a conditioning prod-
uct for Black hair. She was widely known throughout
Harlem for her contributions to Black institutions and
for her musicals, balls, and dinner parties. Walker moved
to Harlem in 1913 and had two townhouses built for her
elaborate salon at 110 West 136th Street and her home at
108 West 136th Street. When she died in 1919, her will
stipulated that two-thirds of her fortune go to a number
of charities and that her company always be controlled by
a woman.[1]

In 1928, Madame Walker's daughter, A'Lelia Walker,
turned one of the townhouses into a tea salon for writers
and artists. A'Lelia named the salon the Dark Tower after
a column in the Urban League's *Opportunity* magazine,
written by Countee Cullen. The salon became a popular
meeting place for artists and social elites. It was decorated
with stylish rosewood furniture, a rosewood piano, rose-
colored curtains, and a sky-blue Victrola player (early
phonograph), and on opposite walls were written poetic
verses by Countee Cullen and Langston Hughes. Unlike

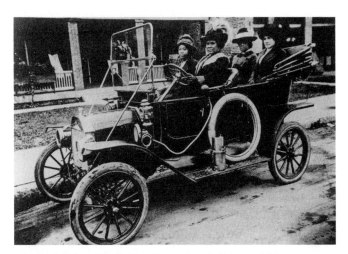

FIGURE 3. Madam C. J. Walker (*driving*) with (*left to right*) her niece Anjetta Breedlove, company forewoman (manager) Alice Kelly, and secretary Lucy Flint (*Photographs and Prints Division, Schomburg Center for Research in Black Culture, The New York Public Library, Astor, Lenox and Tilden Foundations*)

Madame Walker's soirees, however, A'Lelia's parties were not always quiet poetry readings. Some attracted young vanguard artists and writers such as Langston Hughes, Zora Neale Hurston, and others who were eager to express their cultural, artistic, and sexual freedom without boundaries. One Harlemite recalled that some of the gatherings were "funny parties" frequented by "men and women, straight or gay. They were kinds of orgies. Some people had clothes on, some didn't. People would hug and kiss on pillows and do anything they wanted to do. You

could watch if you wanted to. Some came to watch, some came to play."[2]

Presently the building occupying this site is the Countee Cullen branch of the New York Public Library.

➤ Continue walking on the south side of 136th Street westward to find Site 4.

Tour 1, Site 4
Tempo Club

138 West 136th Street (south side of street)

James Reese Europe's Tempo Club was established here in 1914. Europe's fame and professional success were established on several fronts. He was a famous composer and a popular and influential bandleader who incorporated Black musical forms (such as the blues) into orchestrated music ensembles. He challenged policies of racial segregation by bringing his orchestras to perform in Carnegie Hall on several occasions throughout his career. He also broadly introduced Black music to white audiences through his affiliation with the popular white dance team Vernon and Irene Castle. As a booking agent for Black musicians, he broke down racial hiring practices by bringing Black orchestras and bands to perform at white, eastern-seaboard resorts. Europe was a lieutenant during

World War I, and he led a large orchestra of Black musicians affiliated with the heroic 369th Infantry Regiment (aka the Harlem Hell Fighters). The Hell Fighters' orchestra led a widely celebrated victory march through Harlem at the end of the war. Europe's Tempo Club orchestras often comprised one hundred or more band members who entertained in "Musical Melange" and "Dance Festivals" for Harlemites and the broader Black public in the first few decades of the twentieth century. The Tempo Club is presently a private residence.

To read more about early twentieth-century musical entertainment (vaudeville theater and minstrelsy), see page 167.

► Continue walking westward across Adam Clayton Powell Jr. Boulevard (Seventh Avenue) and cross to the north side of the street. Look back across the street to find Site 5.

Tour 1, Site 5
New York Urban League

202–206 West 136th Street (south side of street)

The Urban League served as a Harlem-based community organization facilitating southerners' settlement into New York during the Great Migration. During the 1930s

Harlem Arts Movement, the Urban League also facilitated foundational monetary grants allotted to Harlem artists. The same site has been the New York Urban League's home since 1923.

→ Continue walking westward on the north side of the street to find Site 6.

Tour 1, Site 6
Office of the Brotherhood of Sleeping Car Porters

239 West 136th Street (north side of street)

This is the former office of the Brotherhood of Sleeping Car Porters. In 1937, the first Black American trade union in the United States was organized by social activist Asa Philip Randolph. From 1868, African American men had been recruited to work as service porters for overnight passengers in the sleeping cars of trains. The porters worked for little pay, virtually no job security, and borderline dignity until Randolph successfully organized the porters into unionization. After twelve years of organizing, Randolph won a collective bargaining agreement for the porters. Following the establishment of the porters' union, Randolph continued to use his organizing skills in support of the civil rights marches in the 1940s, '50s,

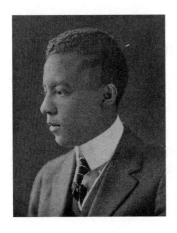

FIGURE 4. Asa Philip Randolph *(Photographs and Prints Division, Schomburg Center for Research in Black Culture, The New York Public Library, Astor, Lenox and Tilden Foundations)*

and '60s alongside activists such as Adam Clayton Powell Jr. and Martin Luther King Jr. His office for the 1941 March on Washington was located in the Theresa Hotel on 125th Street.

Presently the Office of the Brotherhood of Sleeping Car Porters is an unoccupied private building.

To read more about civil rights and social justice movements, see page 151.

► Continue walking westward on 136th Street to find Site 7.

Tour 1, Site 7
"Niggerati Manor"

267 West 136th Street (north side of street)

In 1927, writer and editor Wallace Thurman's apartment at 267 West 136th Street became a cultural and political gathering place for young, progressive Harlem artists such as Langston Hughes and Zora Neale Hurston. The names "Niggerati Manor" and, those who frequented it, the "Niggerati" were coined by Thurman and the ever facetious

FIGURES 5 & 6. *Left:* Langston Hughes *(Photographs and Prints Division, Schomburg Center for Research in Black Culture, The New York Public Library, Astor, Lenox and Tilden Foundations); Right:* Zora Neale Hurston *(Library of Congress, Prints and Photographs Division; photo by Carl Van Vechten; © Van Vechten Trust)*

Hurston in response to Harlem Renaissance elders and their endeavors to create relatively conservative representations of Black art and literature—a development that came to be known as the New Negro Movement. Additionally, mainstream white society had established practices that were highly stigmatizing of African Americans and Africans. The term "Niggerati" was created to circumvent authoritative representations for Blacks regardless of their origin.[3] The original building of "Niggerati Manor" has been replaced with a new residential building.

To read more about the New Negro Movement and "Niggerati Manor," see page 161.

▶ **Look directly across the street to find Site 8.**

Harlem Art Workshop, Location No. 2

270 West 136th Street (south side of street)

In the 1930s, the Harlem Art Workshop and Studio offered classes taught by artists James L. Wells, Palmer Hayden, and Charles Wells in drawing, painting, sculpture, mask making, block printing, and linoleum-cut work. The original site has been replaced with a new building.

To read more about the 1930s Harlem Arts Movement, see page 158.

➤ Walk westward across Frederick Douglass Boulevard (Eighth Avenue) and continue to near the block's end to find Site 9.

Tour 1, Site 9

Uptown Art Laboratory and Harlem Artists Guild

321 West 136th Street (north side of street)

Around 1934, sculptress and teacher Augusta Savage began offering art classes at the Uptown Art Laboratory, located in the garage for 321 West 136th Street. At the same location, the Harlem Artists Guild was formed to hold

FIGURE 7. Uptown Art Laboratory / Harlem Artists Guild (*K. Taborn, 2017*)

meetings for a community artists' activist organization. Included among guild members were Savage and painters Charles Alston and Aaron Douglas. The guild's constitution stated, "We, the artists of Harlem, being aware of the need to act collectively in the solution of the cultural, economic, social and professional problems that confront us, do hereby constitute ourselves an organization that shall be known as the Harlem Artists Guild."[4] Today, the existing building for the Uptown Art Laboratory / Harlem Artists Guild is a private residence.

To read more about the 1930s Harlem Arts Movement, see page 158.

➤ Walk back eastward to Frederick Douglass Boulevard and turn left (north) to 137th Street. Turn right (east) on 137th Street and walk on the south side of the street to find Site 10.

Tour 1, Site 10
John Henrik Clarke Residence

228 West 137th Street (south side of street)

This building was the former residence of John Henrik Clarke, a noted intellectual, author, and educator from the late 1940s until his death in 1998. He wrote, edited,

and contributed to numerous books and articles on Black history, and he was a leader in the establishment of Black studies academic programs such as Hunter College's Black and Puerto Rican Program in 1969. He was also instrumental in the establishment of Cornell University's Africana Studies and Research Program, and he founded the African Heritage Studies Association in 1968. Clarke House, a building named in honor of the educator, is located at 286 Convent Avenue (see Tour 4). The former Clarke residence is currently a privately occupied home.

➤ Continue walking eastward on 137th Street and cross to the north side of the street to find Site 11.

Tour 1, Site 11
Barbara Ann Teer Residence

213 West 137th Street (north side of street)

Activist, writer, actress, producer, teacher, and dancer Barbara Ann Teer (1937–2008) was the founder of the National Black Theatre (NBT, 1968–present; see Tour 3) at 125th Street and Fifth Avenue in Harlem. Following a successful career as an actress and dancer, Teer resolved that it was necessary to create Black owned and operated cultural institutions where Black artists could speak, perform, and interact free of white infringement and domination. To

this effect, performances at Teer's National Black Theatre were developed to foster community, African- and African American–centered, "call and response" interaction between audience and stage performers. Teer's home on 137th Street and the NBT feature African sculptures and artifacts throughout. The Barbara Ann Teer home is presently owned and occupied by Teer family members.

➤ **Continue walking eastward on 137th Street across Adam Clayton Powell Jr. Boulevard and cross back to the south side of the street to find Site 12.**

Tour 1, Site 12
Mother AME Zion Church

140–148 West 137th Street (south side of street)

This extraordinarily historical and culturally rich church is the oldest African American congregation in New York. It was formed in downtown Manhattan in 1796 as the John Street Church—a mixed-race congregation that included white abolitionists. However, segregationist policies held sway in seating (and likely in other areas too), which disillusioned the original Black membership. In 1820, Black members of the church decided to form their own African Methodist Episcopal (AME) church, and they met at several downtown locations before building their present church on 137th Street in Harlem in 1925. A leader of

the early downtown congregation, James Varick, affirmed that no one would be discriminated against because of race, color, or condition, and during the era of slavery, the church became an advocate for runaway slaves with its abolitionist publication the *Freedom's Journal*. Moreover, the church was a refuge for runaway slaves, hiding them during their escape to freedom with a secret passageway behind the church's pulpit. Noted Black abolitionists and escaped slaves flocked to the church, including Frederick Douglass, Sojourner Truth, and Harriet Tubman.

In New York State, AME churches sprang up wherever the abolitionist agenda prevailed, but the word "Mother" was exclusively used for the New York City church to designate its congregation as the original AME church in the state. When relocated to 137th Street, the congregation commissioned one of the first Black architects, George W. Foster, to construct its impressive neo-Gothic structure, and a host of illustrative Black Harlemites became members or frequent visitors. Dr. Benjamin C. Robeson (brother of actor, singer, and activist Paul Robeson) served as reverend from 1936 to 1963. During Robeson's leadership, Langston Hughes, W. E. B. Du Bois, Marian Anderson, Roland Hayes, Joe Louis, and Paul Robeson frequently attended the church, and occasionally Paul Robeson spoke from the pulpit. In 1972, the church opened the James Varick Community Center, one block south, at 151 West 136th Street, to serve the neighborhood's homeless and to provide day

care and programs for youth. The church was designated a landmark by New York's Landmark and Preservation Commission in 1991.[5]

The original church building remains in place today.

═══════════════════════════════════════

To read more about civil rights and social justice movements, see page 151.

➤ Walk back westward to Adam Clayton Powell Jr. Boulevard and turn right (north) to 138th Street. On the southeast corner is Site 13.

Tour 1, Site 13
Renaissance Casino and Ballroom

150 West 138th Street (southeast corner of Adam Clayton Powell Jr. Boulevard)

"The Rennie" was a well-known, nine-hundred-seat entertainment center in the early 1900s that was Black owned and operated. It featured dances and musical concerts led by Duke Ellington and other well-known orchestras. It was also the home to the all-Black Renaissance Five basketball team, with portable basketball hoops used on game nights, which were followed by dancing. After several years of abandonment at this site, construction is in place for low- to moderate-income housing.

Walk eastward on the south side of Odell Clark Place / 138th Street to find Site 14.

Tour 1, Site 14
Abyssinian Baptist Church

132 Odell Clark Place / West 138th Street (south side of street)

Abyssinian congressional members purchased lots on 138th Street between Seventh and Lenox Avenues in 1920. Under the leadership of the Reverend Adam Clayton Powell Sr., the congregation raised the funds to build a church in Gothic and Tudor architectural styles and an

FIGURE 8. Abyssinian Baptist Church (*K. Taborn, 2017*)

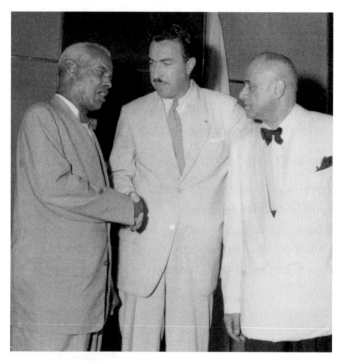

FIGURE 9. Adam Clayton Powell Jr. (*center*) with labor leader Ashley Totten (*left*) and physician James L. Wilson (*right*), at a gathering of the American Virgin Islands Civic Association, ca. 1950s *(Photo by Austin Hansen, used by permission of the Estate of Austin Hansen; Photographs and Prints Division, Schomburg Center for Research in Black Culture, The New York Public Library, Astor, Lenox and Tilden Foundations)*

accompanying community center. Adam Clayton Powell Jr. followed his father into the pulpit, becoming pastor at Abyssinian Baptist Church in 1937. He became a forceful advocate for racial and civil rights in Harlem in the 1930s,

speaking for Harlem's poor and against racial discrimination. From 1961, upon his entry into national politics as a U.S. congressman, Powell became a voice for all working-class Americans. Abyssinian Baptist Church and its congregation remain a stronghold, addressing educational and housing needs in Harlem today.

There has been no significant change in the church's location and use.

To read more about civil rights and social justice movements, see page 151.

➤ Continue walking eastward on Odell Clark Place / 138th Street to find Site 15.

Tour 1, Site 15
Liberty Hall / Garvey Site

120 Odell Clark Place / West 138th Street (south side of street)

In 1919, Marcus Garvey purchased property for a hall here, where he and leaders in his Universal Negro Improvement Association (UNIA) delivered nightly speaking engagements to Garvey's followers. The UNIA was the first massive organization for Black self-determination, where a Back to Africa movement was preached. In *Black*

Manhattan (1930), James Weldon Johnson describes meetings at Liberty Hall as being "conducted with an elaborate liturgy. The moment for the entry of the 'Provisional President' [Garvey] into the auditorium was solemn; a hushed and expectant silence on the throng, the African Legion and Black Cross nurses flanking the long aisle and coming to attention, the band and audience joining in the hymn: 'Long Live our President,' and Garvey, surrounded by his guard of honour from the Legion, marching majestically through the double line and mounting the rostrum."[6] The site is now residential row houses.

To read more about Marcus Garvey and the Universal Negro Improvement Association, see page 165.

➤ **Walk westward back to Adam Clayton Powell Jr. Boulevard. At the southwest corner of 138th Street is Site 16.**

Tour 1, Site 16
Original Red Rooster

2354 Adam Clayton Powell Jr. Boulevard at West 138th Street

The original Red Rooster restaurant was a popular eatery in the 1940s and a favorite watering hole for Adam Clayton Powell Jr. A 1943 article in the *Amsterdam News* listed

the restaurant as the "mecca for the Smart Set after hours," with regulars including Mercer Ellington (orchestral leader and son of "Duke" Ellington) and jazz pianists Teddy Wilson and Hazel Scott, the latter of whom became Powell's second wife in August 1945.[7]

➤ Walk westward on 138th Street to find Site 17.

<div align="center">

Tour 1, Site 17

Striver's Row

West 138th and 139th Streets between Adam Clayton
Powell Jr. and Frederick Douglass Boulevards

</div>

Constructed by developer David H. King Jr. in 1891, rows of beautiful brick and limestone townhouses lining both sides of 139th and 138th Streets between Seventh and Eighth Avenues (aka Frederick Douglass and Adam Clayton Powell Jr. Boulevards) originally housed upper-class, white New Yorkers. King established a reputation constructing mansions for wealthy elites—the Vanderbilts, Astors, and Tiffanys—as well as several elaborate public New York City facilities. The original name for these townhouses was the "King Model Houses." However, the anticipated sales to wealthy, white purchasers failed, and the need to earn back some of the developer's costs eventually gave way to Black purchasers (see the introduction

to this guidebook). Around 1919, Blacks began to purchase the townhouses in the price range of $8,000, and the area eventually became known as Striver's Row. The name was fitting, as not all the occupants were wealthy and some residents rented out their rooms to make ends meet. Nevertheless, the beauty and the historical legacy of the Row has been maintained over the years. Note the turn-of-the-century signs that read, "Walk Your Horses," on gated alleys between townhouses. Today, Striver's Row continues to maintain a predominantly Black middle- and upper-middle-class presence; however, as with Harlem at large, the demographic future of the area has yet to be determined, as the community faces gentrification and other socioeconomic changes under way.

➤ Walk into Striver's Row on 138th Street to find Site 18.

Tour 1, Site 18
William and Isabelle Spiller Residence

232 West 138th Street (south side of street)

The "Musical Spillers" were a husband-and-wife team who led a popular musical show that traveled throughout the United States and Europe. Their home also served as a school, where they taught hundreds of young Harlem music students for over fifty years. The Spillers' basement

FIGURES 10 & 11.
Above: Striver's Row,
139th Street *(K. Taborn,
2017)*
Left: "Walk Your Horses"
sign on Striver's Row
(K. Taborn, 2017)

became a rehearsal studio for several of their well-known musical friends including entertainer Josephine Baker, pianist Claude Hopkins, singer Ethel Waters, tap dancer Bill Robinson, and musician–music publisher W. C. Handy. The site is currently a private residence.

➤ Continue walking westward to find Site 19.

Tour 1, Site 19
Eubie Blake Residence

236 West 138th Street (south side of street)

Eubie Blake boarded a room next to the Spillers. Blake was a master of ragtime and stride piano and a musical collaborator with Noble Sissle; together they composed the music for the Broadway hit *Shuffle Along*. The site is currently a private residence.

➤ Look across the street to view Site 20.

Tour 1, Site 20
Harry C. Pace Residence

257 West 138th Street (north side of street)

Along with W. C. Handy, Harry C. Pace was partner and cofounder of the Pace-Handy Publishing Company after relocating to New York City in 1918. In 1921, Pace and Handy split, and Pace went on to establish the Pace Phonograph Company and the successful Black Swan Record label, which was the first Black-owned music-recording company. The Black Swan company recorded blues, jazz, art songs, spirituals, operatic arias, and instrumental music. The site is currently a private residence.

RECOMMENDED EATERIES

Londel's
2620 Frederick Douglass Boulevard
between 139th and 140th Streets

Serves full meals and drinks, with American soul cuisine; open Tuesdays through Saturdays, 5 p.m. to 11 p.m.; Sunday brunch, 11 a.m. to 5 p.m.

Pony Bistro
2375 Adam Clayton Powell Jr. Boulevard at 139th Street

Serves creative French and West African cuisine; open seven days a week, 11 a.m. to 11 p.m.

➤ Continue walking westward to Frederick Douglass Boulevard and turn right (north) to 139th Street. Turn right and walk eastward on the south side of the street to find Site 21.

<div align="center">

Tour 1, Site 21
W. C. Handy Residence

232 West 139th Street (south side of street)

</div>

In the 1920s, musician W. C. Handy lived at 232 West 139th Street. Handy is credited for publishing Black vernacular songs including the blues, thereby exposing the greater public to Black folk genres. After Handy had established his career in the South and Midwest, he moved in 1918 with his partner lyricist, Harry C. Pace, to Harlem, where their Pace-Handy publishing company became the principal publishing company of Black music. After Pace and Handy separated in 1921, Handy went on to run the Handy Music Company. Handy's songs "St. Louis Blues" (1914) and the even more successful "Beale Street Blues" (1917) established him as "The Father of the Blues." The site is currently a private residence.

➤ Continue walking eastward to find Site 22.

Tour 1, Site 22
Fletcher Henderson Residence

224 West 139th Street (south side of street)

This was the residence of swing bandleader Fletcher Henderson and his wife, Leora. In the 1920s, the Fletcher Henderson Orchestra set a high standard of playing for other orchestras in Harlem. Duke Ellington recalled, "[Henderson's] was the band I always wanted mine to sound like when I got ready to have a big band, and that's what we tried to achieve the first chance we had."[8] With a gift for spotting and hiring extraordinary talent in musicians before they were famous, Henderson hired tenor saxophonists Coleman Hawkins and Lester Young and trumpeters Louis Armstrong and Don Redman to play in his orchestra. Henderson also enjoyed a fruitful career as an accompanist for cabaret and blues singers such as Mamie Smith and Ethel Waters, and he was a regular accompanist employed at Handy and Pace's Black Swan Records. Henderson's home on Striver's Row was frequently visited by blues singers Bessie Smith, Clara Smith, and bandleader Cab Calloway.[9] The site is currently a private residence.

➤ Walk eastward across Adam Clayton Powell Jr. Boulevard to Malcolm X Boulevard. Turn left (north) and walk on the east side of the street to find Site 23.

Savoy Ballroom

596 Malcolm X Boulevard at West 140th Street
(east side of street)

In the 1930s, swing music and the dancing that went along with it reached their peak. With live radio broadcasts of swing bands aired throughout the country, Harlem dance halls were crowded as never before. It was the Savoy Ballroom at 596 Lenox Avenue between 140th and 141st Streets that topped them all. Large enough to hold four thousand people on a fifty- to seventy-five-cent admission charge, two to four bands took turns playing continuous music every night. The best swing bands played the Savoy, led by Jimmy Lunceford, Benny Goodman, Duke Ellington, Earl Hines, Louis Armstrong, Count Basie, Cab Calloway, Fletcher Henderson, Fess Williams, Claude Hopkins, Tommy Dorsey, Teddy Hill, Lionel Hampton, and the most popular of all Savoy bands, the Chick Webb Orchestra with Ella Fitzgerald singing.

By the 1930s, a tradition had been established in America of battles or competitions between the swing bands that were similar to those played out between the earlier stride piano players. The battles often involved bands that represented different cities, such as the May 15, 1927, battle of the Fletcher Henderson and Chick Webb bands, representing New York, versus the King Oliver and Fess

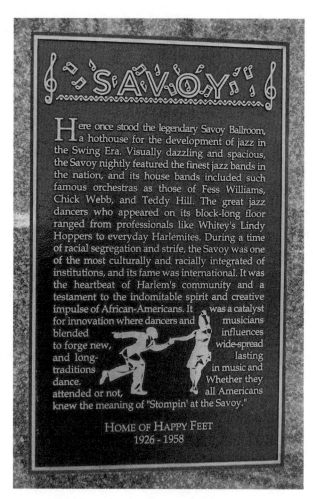

SAVOY

Here once stood the legendary Savoy Ballroom, a hothouse for the development of jazz in the Swing Era. Visually dazzling and spacious, the Savoy nightly featured the finest jazz bands in the nation, and its house bands included such famous orchestras as those of Fess Williams, Chick Webb, and Teddy Hill. The great jazz dancers who appeared on its block-long floor ranged from professionals like Whitey's Lindy Hoppers to everyday Harlemites. During a time of racial segregation and strife, the Savoy was one of the most culturally and racially integrated of institutions, and its fame was international. It was the heartbeat of Harlem's community and a testament to the indomitable spirit and creative impulse of African-Americans. It was a catalyst for innovation where dancers and musicians blended influences to forge new, wide-spread and long- lasting traditions in music and dance. Whether they attended or not, all Americans knew the meaning of "Stompin' at the Savoy."

HOME OF HAPPY FEET
1926 - 1958

FIGURE 12. Plaque on the gate of the Savoy Park Apartments (*K. Taborn, 2017*)

Williams bands, representing Chicago. The most famous battle took place at the Savoy in 1937 between the Chick Webb and Benny Goodman orchestras, at which five thousand people were crowded inside to watch and another five thousand people were turned away.

The Savoy was as popular for the dancing that took place there as it was for its swing bands. A number of dances were developed there, such as the Lindy Hop, Peckin', Truckin', the Suzy Q, and the Congeroo, which were as full of life and creativity as the bands were. The Savoy Ballroom was appropriately nicknamed "the home of happy feet" in honor of the dances that were developed there.[10] See the plaque honoring the Savoy's history at the middle of the gate in front of the Savoy Park Apartments complex, which presently occupies the site.

➤ Keep walking northward. At the northeast corner of 142nd Street and Malcolm X Boulevard is Site 24.

Tour 1, Site 24
Cotton Club

644 Malcolm X Boulevard
(northeast corner of West 142nd Street)

The Duke Ellington Orchestra was at the Cotton Club from 1927 until 1931, when Ellington began alternating his seat with swing bandleader Cab Calloway. The Cotton Club had a whites-only policy for its clientele. Money-making, not racial progress, took precedence. To the mobsters who owned it, moneymaking meant maintaining racially stereotyped images of happy-go-lucky Blacks—often using southern plantation or jungle décor and themes. A typical prerequisite for chorus girls, who were adorned with feathers and fans, was that they be fair complexioned. By 1926, Harlem had become a playground for whites seeking "Negro" entertainment. On any weekend night, there would be cars on the streets parked three rows deep in front of the three main clubs—Connie's Inn, the Cotton Club, and Small's Paradise. A new building, the Minisink Community Center, replaces the former Cotton Club.

➤ Walk back southward on Malcolm X Boulevard to 138th Street and turn left (east) to find Site 25, on the north side of the street.

Tour 1, Site 25
St. Mark's Church and Hall / Marcus Garvey Site

57 West 138th Street (north side of street)

The fiery and charismatic Black leader Marcus Garvey gave his first New York speech at this site in 1916. Garvey established an unprecedented number of businesses for his "Negro self-help" and "return to Africa" movements in Harlem. There have been no significant changes to this site.

For more information about Marcus Garvey and the Universal Negro Improvement Association, see page 165.

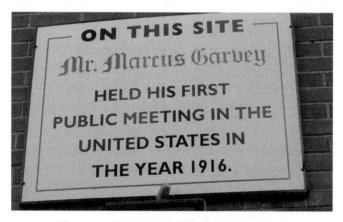

FIGURE 13. Plaque outside St. Mark's Church (*K. Taborn, 2017*)

➤ This concludes Tour 1. To return to the 135th Street / Malcolm X Boulevard subway, continue to walk southward on Malcolm X Boulevard three blocks to 135th Street.

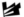

9

137 St

136 St

10 8

-N-

12

13 7 135 St

11

14

Adam Clayton Powell Blvd

15 134 St 4

6 3 2,3
M 1 2

16 18 5

25 17 133 St

24

26 19-22

27 132 St

28

29

23 Malcolm X Blvd / Lenox Ave

131 St

0 250
Feet

Rutgers Cartography 2017

Tour 2

Central Harlem: Middle

Estimated duration: 2 to 2½ hours

1. Subway Mosaics by Willie Birch
2. Speakers' Corner
3. Schomburg Center for Research in Black Culture
4. Harlem Hospital Murals
5. Lenox Terrace and Lincoln Theater / Metropolitan AME Church
6. Original 135th Street Branch of the New York Public Library
7. James Weldon Johnson Residence
8. Harlem Walk of Fame
9. Augusta Savage Workshop No. 2
10. NAACP Headquarters
11. Harlem YMCA
12. Smalls Paradise
13. Hot-Cha Bar and Grill
14. St. Philip's Episcopal Church
15. Barron's Exclusive Club / Monroe's Uptown House
16. Jungle Alley
17. Pod and Jerry's Log Cabin
18. Nest Club / Rhythm Club II
19. Basement Brownies
20. Tillie's Chicken Shack / Covan's Club Morocco / Bill's Place
21. Clam House
22. Mexico's
23. The Frogs Club
24. Basie's Lounge
25. Wells' Upstairs Room
26. Rhythm Club I / Hoofers Club
27. Lafayette Theatre
28. Connie's Inn
29. Tree of Hope

► Take the 2 or 3 subway to the 135th Street station.

Tour 2, Site 1
Subway Mosaics by Willie Birch

135th Street subway station

To read about this site, see Tour 1, Site 1, page 8.

➤ Exit the subway to find Site 2, at the four corners of the intersection of 135th Street and Malcolm X Boulevard (Lenox Avenue).

Tour 2, Site 2
Speakers' Corner

Intersection of West 135th Street and Malcolm X Boulevard

During the 1920s and 1930s, the intersection of Malcolm X Boulevard and 135th Street was known as Speakers' Corner, where impromptu public speakers, often perched on soapboxes, would address the crowds on political, philosophical, and economic issues. A frequent speaker was Marcus Garvey, who would preach to passersby around 1916 about his Back to Africa movement and his philosophy for Black self-help. Around the same time, Black activist Asa Philip Randolph preached a class-conscious philosophy of socialism. Later, in the 1930s, Randolph joined other Black political leaders (Adam Clayton Powell Jr. and still later, in the 1960s, Martin Luther King Jr. and others) in protesting racism in Harlem and nationwide. Lillian Harris Dean,

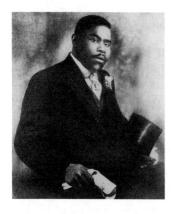

FIGURE 14. Marcus Garvey *(Photographs and Prints Division, Schomburg Center for Research in Black Culture, The New York Public Library, Astor, Lenox and Tilden Foundations)*

aka "Pig Foot Mary," one of the success stories of early Harlem, was a regular on the corner peddling chitterlings, corn, hogmaw, and pig's feet out of a baby carriage. Mary acquired a fortune in properties in Harlem and California, conservatively valued at $335,000, nearly $7 million when converted to 2017 dollars.[1]

To read more about Marcus Garvey and the Universal Negro Improvement Association, see page 165.

➤ **Cross Malcolm X Boulevard to find Site 3, on the northwest corner of the intersection.**

Tour 2, Site 3
Schomburg Center for Research in Black Culture

**Northwest corner of West 135th Street
and Malcolm X Boulevard**

To read about this site, see Tour 1, Site 2, pages 8–11.

➤ Walk northward on Malcolm X Boulevard to 136th Street. Look eastward across the street to see the glass pavilion of Harlem Hospital and then cross Malcolm X Boulevard and enter the building with the glass façade to find Site 4.

Tour 2, Site 4
Harlem Hospital Murals

506 Malcolm X Boulevard at West 136th Street

In 1936, painter Charles Alston became the first African American to supervise a Works Progress Administration (WPA) arts project. Alston oversaw the design and painting of a set of seven murals created by Black artists. The murals depicted the healing practices of ordinary Africans and African Americans. Alston's own mural juxtaposed images of folkloric medicinal applications from preindustrialized Africa with contemporary (1930s) Western medical approaches. A mural painted by Georgette Seabrook

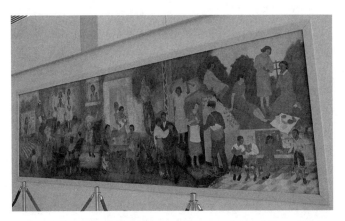

FIGURE 15. Georgette Seabrook's partially restored mural *Recreation in Harlem* on the left side of the Harlem Hospital lobby *(Courtesy of Harlem Hospital Center; photo by K. Taborn, 2017)*

depicted the everyday, communal, and recreational healing methods of African Americans. At the time of installation, the mural project was seen as a political and cultural victory for the Harlem community; however, Harlem Hospital administration officials argued that the themes relied too heavily on Black subject matter and that the demographics of Harlem might differ in the future from its primarily Black populace of the time. Harlem artists banded together under the direction of the Harlem Artists Guild and successfully lobbied for the murals. Alston's WPA supervisory position and the Black-life subject matter of the murals were a direct result of the lobbying efforts of the Harlem Artists Guild. Some of the murals were

restored in 2012 as part of the installation process of the new patient pavilion.[2]

Telephone ahead to enter the Mural Pavilion Room: 212-939-1000. Ask to speak to the Public Affairs Department.

See the Seabrook mural in the lobby of the building. To see more WPA murals by Vertis Hayes, Charles Alston, and others, walk opposite the Seabrook mural, down a short corridor, and turn left.

To read more about the 1930s Harlem Arts Movement, see page 158.

➤ Exiting Harlem Hospital, turn left (south) on Malcolm X Boulevard and walk back to 135th Street to find Site 5, on the southeast corner of the intersection.

Tour 2, Site 5
Lenox Terrace and Lincoln Theater / Metropolitan AME Church

Between West 135th and 132nd Streets and Malcolm X Boulevard and Fifth Avenue / 58 West 135th Street

Look toward the southeast corner of the intersection and the street-level shops to the sixteen-floor Lenox Terrace apartment complex, situated between 135th and 132nd

Streets and Malcolm X Boulevard and Fifth Avenue. Over the years, a who's who of renowned Harlem personalities have called Lenox Terrace home, including New York City assemblyman Lloyd Dickens, civil rights attorney Percy Sutton, governor David Patterson, congressman Charles Rangel, novelist and Black culture critic Albert Murray, and Harlem numbers runner / gangster Ellsworth Raymond "Bumpy" Johnson.[3]

Just in front of Lenox Terrace, at 58 West 135th Street, sits Metropolitan AME Church. In the 1920s, the historically significant Lincoln Theater was located where the Metropolitan AME Church sits today. The Lincoln was the earliest large theater venue catering to a Black clientele. It showed a new motion picture weekly, interspersed with vaudeville, jazz, and blues entertainment. Two of the film stars featured were Mary Pickford and Gloria Swanson. Live shows featured acts such as blues singer Mamie Smith in 1926 and jazz pianist Clarence Williams in 1925. In 1927, blues singer Clara Smith held court in her "intimate revue with an all-star cast" of thirty supporting performers, while stride-jazz pianist Thomas "Fats" Waller delighted the audience hourly at the organ.

► Walk westward across Malcolm X Boulevard and cross to the north side of 135th Street to find Site 6.

Tour 2, Site 6
Original 135th Street Branch of the New York Public Library

103 West 135th Street (north side of the street)

Funds for the construction of the Italian Renaissance palazzo building at this site were donated by Andrew Carnegie in 1901, and the library opened in 1904 to service what at the time was a burgeoning Jewish community. By the 1920s, the demographics of the neighborhood had shifted to a 50 percent Black population. Black librarians Regina Andrews, Catherine Latimer, and Nella Lance were hired by the senior librarian, Ernestine Rose, and the 135th Street library quickly became the intellectual hub of Harlem. In 1926, the library purchased the original Schomburg collection of five thousand books, three thousand manuscripts, and two thousand etchings and paintings by Black creators, and Arthur Schomburg served as curator of the Negro Division of Literature, History, and Prints from 1932 to 1938. In the 1920s, poetry and literary gatherings were attended by Countee Cullen and Langston Hughes. In the 1930s, artists James Wells and Charles Alston directed the library's Art Workshop, and the library was a frequent refuge for writer James Baldwin; it is where Baldwin sharpened his literary and intellectual talents.[4]

During the 1930s, the theatrical wing of the Works Progress Administration was the Federal Theatre Project, or

FIGURE 16. Original 135th Street branch of the New York Public Library (*K. Taborn, 2017*)

FTP. The theatrical community in Harlem benefited from the program through funding for the American Negro Theater (ANT), which existed from 1940 to the mid-1950s and was initially housed in the basement of the New York Public Library on 135th Street. The direction of ANT was set by two African Americans, playwright/director Abram Hill and actor Frederick O'Neal, to enable disciplined theatrical training toward the production of theater that fostered a realistic reflection of Black life, heretofore non-existent in the white-dominated world of theater. Several noted actors received early training at the ANT, including Sidney Poitier, Ruby Dee, and Harry Belafonte.

The interior of the building is now connected to the Schomburg Center; although the original front entrance on 135th Street is closed, the façade has been retained for aesthetic purposes.

► Continue walking westward. Near the end of block is Site 7.

Tour 2, Site 7
James Weldon Johnson Residence

187 West 135th Street (north side of the street)

James Weldon Johnson, an active participant in the Harlem Renaissance on several fronts, lived in an apartment in this building in the 1920s. Johnson was a poet, novelist, songwriter, diplomat, editorial contributor to the *New York Age* newspaper, and executive secretary to the NAACP. Also an accomplished musician and lyricist, Johnson collaborated with one of the most popular early twentieth-century vaudeville musical duos, which included his brother, J. Rosamond Johnson, and Bob Cole. A lasting musical accomplishment of the Johnson brothers is the song that came to be known as the "National Negro Anthem," "Lift Ev'ry Voice and Sing," with James Weldon contributing the lyrics and J. Rosamond composing the music.

Presently, the building continues to be used for apartment rentals.

➤ Walk westward across Adam Clayton Powell Jr. Boulevard (Seventh Avenue) and then continue on the north side of 135th Street about a quarter into the block to see the first sidewalk plaque of Site 8.

Tour 2, Site 8
Harlem Walk of Fame

135th Street between Frederick Douglass and Adam Clayton Powell Jr. Boulevards, both sides of the street

Bronze sidewalk plaques line both sides of the street here honoring the artists, writers, musicians, and politicians from Harlem's rich history. The Walk of Fame was installed in 1993–1994 as part of a revitalization project initiated by the New York City Economic Development Corporation.

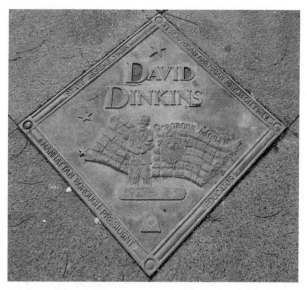

FIGURE 17. Mayor David Dinkins's plaque on the Harlem Walk of Fame (*K. Taborn, 2017*)

► Continue walking westward on the north side of 135th Street to find Site 9.

Tour 2, Site 9
Augusta Savage Workshop No. 2

239 West 135th Street (north side of street)

A new building replaces the former site of sculptress Augusta Savage's second workshop at 239 West 135th Street. Ever since returning from studying art in Europe in 1931, Savage had been providing Harlem youth art classes, free of charge in her basement at 163 West 143rd Street. In 1933, she secured $1,500 from the Carnegie Foundation that was administered by the National Urban League for her art classes. Savage used the funds to move her studio to a garage attached to 239 West 135th, and she established herself as a forceful advocate for Harlem artists. She organized and promoted her students' works in exhibits throughout and beyond Harlem, and she spearheaded the community-centered Harlem Artists Guild. When the highly revered Harlem Community Arts Center opened in 1937, Savage was appointed as the first director. This site is presently a private residence.

To read more about Augusta Savage and the 1930s Harlem Arts Movement, see page 158.

➤ Continue walking westward along the Harlem Walk of Fame to Frederick Douglass Boulevard. Then cross over to the south side of 135th Street to walk back eastward toward Adam Clayton Powell Jr. Boulevard to find Site 10.

Tour 2, Site 10
NAACP Headquarters

224 West 135th Street (south side of street)

This building was the headquarters for the National Association of Colored People (NAACP) in the early twentieth century. The NAACP was founded in 1909 by an interracial group of Black and white social reformers to eradicate racial prejudice and race discrimination. With the influential editor W. E. B. Du Bois at the helm of the NAACP's publication, the *Crisis*, the organization played a crucial role in providing national exposure for young Black writers and artists in the early twentieth century. Today the building is a private residential building with a beauty salon on the ground floor.

To read more about civil rights and social justice movements, see page 151. To read more about W. E. B. Du Bois, the New Negro Movement, and "Niggerati Manor," see page 161.

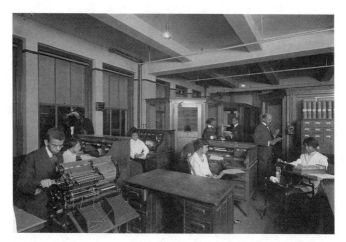

FIGURE 18. W. E. B. Du Bois and staff in the *Crisis* publishing office, ca. 1900–1930 (*Photographs and Prints Division, Schomburg Center for Research in Black Culture, The New York Public Library, Astor, Lenox and Tilden Foundations*)

➤ Continue walking eastward on 135th Street across Adam Clayton Powell Jr. Boulevard and cross to the south side of the street to find Site 11, located a few doors into the block.

Tour 2, Site 11
Harlem YMCA

180 West 135th Street (main building; south side of the street)

The Y has been an important site for art and theater in Harlem throughout the years. During the 1920s, the Y presented plays by Black playwrights and actors. In 1928,

W. E. B. Du Bois organized a theater group here called the Krigwa Players. Many theater companies were organized with the intention of countering derogatory images of Blacks that were often presented in Broadway revues at the time. It was here that Paul Robeson and other Black actors made their first stage appearances before embarking on national and international acting careers.[5]

The Y also provided lodging for notable Harlemites. When Langston Hughes first arrived in Harlem in 1921, he lodged most frequently at the Y, as well as at the home of Countee Cullen at 234 West 131st Street; Cullen befriended Hughes soon after his arrival.[6] See Aaron Douglas's mural *The Evolution of Negro Dance*, installed here in 1933 (located in the Children's Gym). The mural depicts Black contributions in dance and music to world culture.

To read more about the 1930s Harlem Arts Movement, see page 158.

➤ Walk back westward to Adam Clayton Powell Jr. Boulevard, cross over to the west side of the street, and turn left (south) to find Site 12.

Tour 2, Site 12
Smalls Paradise

2294½ Adam Clayton Powell Jr. Boulevard (west side of street)

Of the three large music venues in the 1920s (the others were the Cotton Club and Connie's Inn), Smalls Paradise (1925–1964) was the only one that was Black owned and operated and that allowed Blacks in the audience. An evening at Smalls included the house orchestra, singers and dancers, and a featured cabaret singer. The atmosphere of Smalls most realistically reflected the joie de vivre of Harlem. Trumpeter Rex Stewart remembered "the waiters, who not only created the Charleston, but also served drinks while dancing with a tray on top of their heads!" A 1928 advertisement for the club listed midnight to two a.m. shows including comedian Jackie "Moms" Mabley with "a real beauty dancing ensemble of winson [sic] maids" following Charlie Johnson's musical revue.[7]

Smalls was still going strong in the early 1940s when Malcolm X—then known as "Detroit Red"—began waiting tables there. Beyond Harlem's glamorous façade of entertainers and celebrities, a thriving hustler's world of numbers runners, prostitution, and crime prevailed. "Red" was soon sucked in and became a hustler himself, leading up to serving seven years of a prison sentence from 1946 to 1952.[8] In 1952, he resurfaced in Harlem as the charismatic Nation of Islam (NOI) political leader

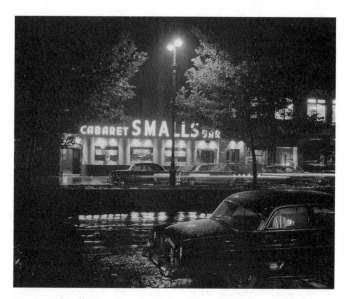

FIGURE 19. Smalls Paradise, 1955 *(Photo by Austin Hansen; used by permission of the Estate of Austin Hansen, Photographs and Prints Division, Schomburg Center for Research in Black Culture, The New York Public Library, Astor, Lenox and Tilden Foundations)*

Malcolm X and the chief minister at Harlem's NOI Temple No. 7. The site is currently an International House of Pancakes restaurant.

➤ Continue walking southward on Adam Clayton Powell Jr. Boulevard to the northwest corner of 134th Street to find Site 13.

Tour 2, Site 13
Hot-Cha Bar and Grill

2280 Adam Clayton Powell Jr. Boulevard
(northwest corner of 134th Street)

In the 1930s, the Hot-Cha Bar and Grill was one of the clubs where Billie Holiday held an extended engagement. Following another lengthy stay at Pod and Jerry's Log Cabin on Jungle Alley (133rd Street), Holiday became a regular at the Hot-Cha Bar in 1934. During the intermissions, pianist Garland Wilson entertained guests from a balcony.[9] The site is currently a small private business.

➤ Walk westward on the south side of 134th Street a few doors down to find Site 14.

Tour 2, Site 14
St. Philip's Episcopal Church

204 West 134th Street (south side of street)

St. Philip's was the oldest African American Episcopal parish in New York City, established in the Wall Street area of Manhattan in 1809. The downtown congregation of the church was originally affiliated with the mixed-race Trinity Church, until Black members separated and established the Free African Church of St. Philip's in 1809. The

FIGURE 20. St. Philip's Episcopal Church *(K. Taborn, 2017)*

church's first rector, Peter Williams Jr., was a prominent abolitionist. As with several other Harlem churches, the congregation tithed its monies together to build its current spiritual and religious Harlem home, constructed in 1910–1911. The neo-Gothic structure was designed by Black architects Vertner Woodson and George Washington Foster. Former parishioners included W. E. B. Du Bois, Langston Hughes, and Thurgood Marshall.

➤ Walk back eastward across Adam Clayton Powell Jr. Boulevard. On the southeast corner of 134th Street is Site 15.

Tour 2, Site 15
Barron's Exclusive Club / Monroe's Uptown House

198 West 134st Street (southeast corner of
Adam Clayton Powell Jr. Boulevard)

Barron's Exclusive Club (1915–1926) was one of the earliest
Black-owned speakeasies in Harlem. Around 1915, Bar-
ron D. Wilkins opened the club, featuring cabaret singer/
dancer Ada "Bricktop" Smith and stride pianists Charles
"Luckey" Roberts, James P. Johnson, and Willie "The Lion"
Smith. Burgeoning musician Edward "Duke" Ellington
and his band were also regularly featured. On the rec-
ommendation of Ada "Bricktop" Smith, Ellington landed
a regular gig at Barron's in 1923, soon after his arrival in

Harlem.[10] The club was a frequent hangout for mobsters during the Prohibition era, and Ellington recalled,

> [Barron's] was considered absolutely the top spot in Harlem, where they catered to big spenders, gamblers, sportsmen, and women, all at the peak of their various professions. People would come in who would ask for change for a C-note [$100 bill] in half dollar pieces. At the end of a song, they would toss the two hundred four bit pieces up in the air, so that they would fall on the dance floor and make a jingling fanfare for the prosperity of our tomorrow. The singers—four of them, including Bricktop—would gather up the money and another hundred dollar bill would be changed, and this action would go jingling deep into the night. At the end of the evening, at 4 a.m. or maybe 6, our bountiful patron thought we had had enough setting up exercises picking up halves, he would graciously thank us and wish us good luck.[11]

Barron's management and the name of the club were changed a number of times, to the Theatrical Grill, the Pirate's Den, the Red Pirate, and finally Monroe's Uptown House, when Clark Monroe took it over and featured bebop musicians in 1936.

Monroe's Uptown House (1936–1943) was a popular joint for bebop musicians including Charlie Parker, Dizzy Gillespie, and Roy Eldridge. Clark Monroe was one of the few Black club owners in Harlem and an important con-

tributor to the development of the music. After Monroe's Uptown House closed, Monroe opened a host of clubs— the first Black-run clubs downtown on 52nd Street, including the Downbeat, the Famous Door, the Spotlight, and the Royal Roost. The site is currently the 134th Street Deli.

═══════════════════════════════════════

To read more about the development of bebop (jazz) in Harlem, see page 171.

➤ **Walk southward on Adam Clayton Powell Jr. Boulevard to 133rd Street and make a left, walking eastward toward Malcolm X Boulevard, to find Site 16.**

Tour 2, Site 16
Jungle Alley

West 133rd Street between Malcolm X and Adam Clayton Powell Jr. Boulevards

This was the most populated street for speakeasies during the Prohibition era (1920–1933), with twelve or more speakeasies and eateries on the block.[12]

═══════════════════════════════════════

To read more about speakeasies, small clubs, Jungle Alley, and stride piano players, see page 173.

➤ Walk eastward on the south side of the street to find Site 17.

Tour 2, Site 17

Pod and Jerry's Log Cabin

168 West 133rd Street (south side of street)

Pod and Jerry's Log Cabin opened as a speakeasy in 1925 and continued until 1935. After Prohibition ended in 1933, one of the owners remodeled the entrance to look like a log cabin. The site was an important venue for cabaret singers such as Mary Stafford, Mattie Hite, and Big Red and a humpbacked baritone by the name of "Little Jazzbo" Hilliard, as well as stride pianists.[13] However, the club has gone down in history as the venue where Billie Holiday got her start singing. In 1933, at the age of eighteen, Holiday was desperate to help her mother pay the rent. She found work singing at Pod and Jerry's Log Cabin on "the Alley."

> I walked down Seventh Avenue from 139th Street to 133rd Street, busting in every joint trying to find a job. In those days 133rd Street was the real swing street, like 52nd Street later tried to be. It was jumping with after hours spots, regular hour joints, restaurants, cafés, a dozen to a block. Finally, when I got to Pod's and Jerry's, I was desperate. I went in and asked for the boss. . . . I told him I was a dancer and I wanted to try out. I didn't even know the word "audition" existed, but that was what I wanted.[14]

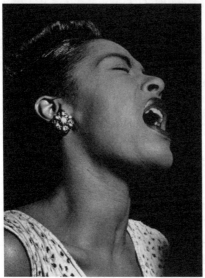

FIGURES 21 & 22.

Above: Former site of Pod and Jerry's Log Cabin *(K. Taborn, 2017)*

Left: Billie Holiday *(William P. Gottlieb / Ira and Leonore S. Gershwin Fund Collection, Music Division, Library of Congress)*

Holiday failed miserably in the audition as a dancer, but before they threw her out, the piano player asked, "'Girl, can you sing?' . . . 'Sure,'" she replied, and she broke into a chorus of the song "Trav'lin' All Along."[15] The rest is history. Following an ongoing engagement at Pod and Jerry's, Billie went on to perform at a host of Harlem clubs. In 1937, she joined and toured with the Basie Band, and Holiday won the hearts of Harlemites by singing in a uniquely relaxed, yet swinging way. As John Hammond described it, "You never heard singing so slow, so lazy, with such a drawl. . . . It ain't the blues. I don't know what it is, but you got to hear her."[16] The former Pod and Jerry's is now a small church.

➤ Look directly across the street at the current site of the Nest Community Health Center. This is the location of Site 18.

Tour 2, Site 18
Nest Club / Rhythm Club II

169 West 133rd Street (north side of street)

The Nest Club (1925–1930s) was a popular club that was controlled by the mob. It featured medium-sized bands of seven or eight musicians. The Rhythm Club II, located in the back room of the Nest (1932–1950), was carried over from the Rhythm Club I (corner of 132nd Street

and Adam Clayton Powell Jr. Boulevard). The original Rhythm Club changed its featured entertainment to dancers in 1932, and the musicians moved their nightly jam sessions over to the Rhythm Club II. As stride pianist Willie "The Lion" Smith recalled, both Rhythm Clubs were the most popular hangouts for instrumentalists, where young musicians would go to learn how to play and to be heard. Smith recalled,

> Many jazz figures were first heard [there] and leaders like [Fletcher] Henderson, [Duke] Ellington, Elmer Snowden, and Charlie Johnson would go there to hire their sidemen. Usually the big action didn't start until 3 a.m., because that was when all the guys playing in the commercial bands got off. They had a house band hired to work the four hours between 3:30 and 7:30 a.m., but many times they were kept going well in the new day. . . . On one visit, you could hear playing, one after the other, the Lion [referring to himself in the third person], Luckey Roberts, Fats, James P., and Duke, all working on individual interpretations of some popular tune of the day. . . . There were cornet players, . . . trombone players. In another line would be the reedmen. . . . As time went on, the club became a hangout for all entertainers.[17]

This site is now the Nest Community Health Center.

➤ Continue walking eastward on the south side of the street to find Site 19.

Tour 2, Site 19
Basement Brownies

152 West 133rd Street (south side of street)

In a club that was at this site from 1930 to 1935, the virtuoso pianist Art Tatum was frequently heard, along with stride masters Thomas "Fats" Waller, Willie "The Lion" Smith, and James P. Johnson. This site is now a vacant lot.

► Continue walking eastward to find Site 20.

Tour 2, Site 20
Tillie's Chicken Shack / Covan's Club Morocco / Bill's Place

148 West 133rd Street (south side of the street)

Tillie's Chicken Shack (ca. 1928–1930) was a popular chicken eatery as well as one of the favored rooms to hear stride pianists such as Thomas "Fats" Waller, Bob Howard, and "Fats" Joyner. The proprietor was an industrious rags-to-riches female entrepreneur, Tillie Fripp, who established a reputation as a culinary queen after arriving in Harlem in 1926. Composer Walter Donaldson once challenged Waller to play Donaldson's song "My Blue Heaven" as many times as he could, and Donaldson offered to buy Waller a drink each time the song was played. The story

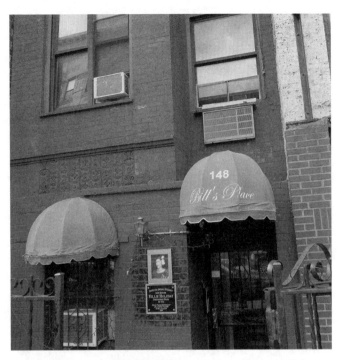

FIGURE 23. Former site of Tillie's Chicken Shack and Covan's Club Morocco; currently Bill's Place *(K. Taborn, 2017)*

has it that Waller ran through the song twenty-five times and downed just as many drinks.[18] Covan's Club Morocco took over Tillie's around 1930, moving from 132nd Street. The club featured singers Monette Moore and later Mae Barnes in the 1930s, and guitarist Slim Gaillard and bassist Slam Stewart, known as "Slim and Slam," introduced their hip scat-singing routine here. Today at the former site for

Tillie's Chicken Shack and Covan's Club Morocco is Bill's Place, the only jazz club on the former Jungle Alley. The club is run by saxophonist Bill Saxton and Theda Palmer-Saxton. Call to make reservations to attend an evening of jazz entertainment in Harlem: 212-281-0777.

➤ Next door is Site 21.

Tour 2, Site 21
Clam House

146 West 133rd Street (south side of the street)

The Clam House (1925–1933) was another early-morning music spot that featured Gladys Bentley at the piano, singing sexually explicit songs while dressed in drag.

➤ A couple of doors down is Site 22.

Tour 2, Site 22
Mexico's

140 West 133rd Street (south side of the street)

Mexico's (1928–1936) was a favorite spot for a youthful Duke Ellington, who was highly influenced by stride piano playing, which he incorporated into his own style of play-

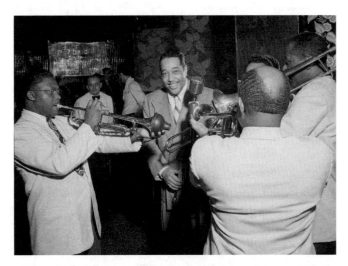

FIGURE 24. Duke Ellington (*William P. Gottlieb / Ira and Leonore S. Gershwin Fund Collection, Music Division, Library of Congress*)

ing. Ellington recalled Mexico's as a popular after-after-hours spot for battles of music that was frequented by the Ellington band in the late 1920s.

Mexico's was the scene of many battles of music. Every Wednesday night there would be an open blowing competition. A different instrument was featured each Wednesday. One week it would be cornets, another week alto saxophones, a third clarinets, and so on, until it became the turn of the tuba players. The joint was so small only one or two tubas could be in the place at one time. The other tubas had to line up on the curb outside, and wait for their turn. Virtuoso combat was the most popular form of sport

for the professional musician in those days. I shall never
forget the night Fats Waller, James P. Johnson, and "the
Lion" tangled there. Too bad there were no tape recorders
in those days.[19]

The site is currently a residential apartment building.

➤ Walk eastward to Malcolm X Boulevard and turn right (south)
to 132nd Street. Turn right again onto 132nd Street, walking west-
ward on the north side of the street, to find Site 23.

Tour 2, Site 23
The Frogs Club

III West 132nd Street

The Frogs was a social club composed of the most suc-
cessful Black entertainers and writers from vaudeville
entertainment at the turn of the century. They established
a clubhouse here in 1909. The motive of the club was to
archive the entertainers' and writers' accomplishments, to
present performances for the Harlem public, and to provide
housing for traveling Black performers. The original Frogs
members included orchestra leader and booking agent
James Reese Europe, composers J. Rosamond Johnson
and his music-writing partner Bob Cole, lyricist Alex Rog-
ers, theatrical writer and actor Jesse Shipp, entertainment

FIGURE 25. Willie "The Lion" Smith, 1947 (*William P. Gottlieb / Ira and Leonore S. Gershwin Fund Collection, Music Division, Library of Congress*)

FIGURE 26. The Frogs social club, 1908; *standing, left to right*, Bob Cole, Lester A. Walton, Sam Corker, Bert Williams, James Reese Europe, and Alex Rogers; *seated, left to right*, Tom Brown, J. Rosamond Johnson, George Walker, Jesse A. Shipp, and R. C. McPherson (Cecil Mack), 1908 (*Photo by White Studio; © The New York Public Library for the Performing Arts*)

columnist Lester Walton, and the brilliant vaudeville team of Egbert "Bert" Williams and George Walker. The members of the club had a tremendous influence on early twentieth-century Black theatrical entertainment, including comedy, dance, and music.[20]

This is presently a privately owned, unoccupied building.

===

To read more about vaudeville theater and minstrelsy, see page 167.

► Continue walking westward back to Adam Clayton Powell Jr. Boulevard. On the northeast corner is Site 24.

Tour 2, Site 24
Basie's Lounge

2245 Adam Clayton Powell Jr. Boulevard (northeast corner)

The great pianist and bandleader Count Basie operated a club here from 1955 to 1964, when the Eddie "Lock Jaw" Davis Trio and organist Shirley Scott were regularly featured entertainment.[21] The former site for Basie's is now a vacant storefront.

► Walk northward on the east side of Adam Clayton Powell Jr. Boulevard, on the same block, to find Site 25.

Tour 2, Site 25
Wells' Upstairs Room

2249 Adam Clayton Powell Jr. Boulevard (east side of street)

Wells' Upstairs Room was famous for its chicken and waffles as well as its musical entertainment. It enjoyed a long stretch of popularity from 1938 to 1982. A sign on the wall in the late 1950s stated, "There's always a reason for drinking. One has just entered my head. If you don't drink when you're living, how the hell you gonna drink when you're dead!"[22] The restaurant tried a comeback in the mid-1980s that lasted only a few years. Some of the musicians performing here over time were Mary Lou Williams, "Sissle and Blake," and Billy Taylor. The former site for Well's is now Chez Maty et Sokhna African Restaurant.

➤ Walk back southward to the southeast corner of Adam Clayton Powell Jr. Boulevard and 132nd Street to find Site 26.

Tour 2, Site 26
Rhythm Club I / Hoofers Club

2235 Adam Clayton Powell Jr. Boulevard
(southeast corner of West 132nd Street)

The Rhythm Club was the most popular venue for musicians' jam sessions between 1920 and 1932. Located in the

building's basement was the hottest spot for aspiring instrumental jazz players. Around 1932, the Rhythm Club moved to 169 West 133rd Street (back of the Nest Club on Jungle Alley), and the Hoofers Club replaced the original Rhythm Club.

The Hoofers Club (ca. 1930–1945) was a popular spot for dancers where, according to trumpeter Rex Stewart, dancers were holding jam sessions every night.

> You could see Pete Nugent of Pete, Peaches and Duke, and Bill Bailey (Pearlie Mae's brother) watching Arthur Bryson, of Russian dance fame, challenging Dewey Weinglass on that dance. After that, Peg Leg Bates would demonstrate to Big Time Crip how to execute some of his fantastic one-leg dancing. Other nights, there would be a battle between Snake Hips Tucker and his protégé Snake Hips Taylor. And I might mention that there was always a large audience of dancers, watching and learning how the great ones did it.[23]

The site is currently under construction for a block-long apartment building complex between 132 and 131st Streets.

➤ On the southeast corner of Adam Clayton Powell Jr. Boulevard and 132nd Street is Site 27.

Tour 2, Site 27
Lafayette Theatre

2227 Adam Clayton Powell Boulevard

Seating two thousand people, the Lafayette Theatre (1912–1964) presented large vaudeville shows during the early years when Harlem became a Black enclave. The theater was famous for presenting theatrical plays. Every week the Lafayette Players would stage a new play there. Theater owner Frank Schiffman practiced a policy of exclusivity,

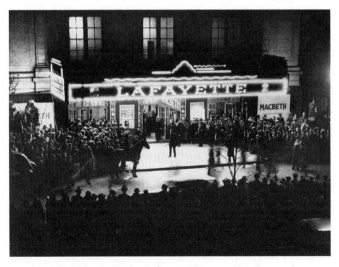

FIGURE 27. Crowd outside the Lafayette Theatre in Harlem at the opening of the play *Macbeth* (*Photographs and Prints Division, Schomburg Center for Research in Black Culture, The New York Public Library, Astor, Lenox and Tilden Foundations*)

and there were penalties for artists performing in other Harlem theaters. Lafayette entertainers were contracted at the unheard-of high salary of $1,000 per week. The contracts made playing the Lafayette the sought-after Harlem venue, beating out other Harlem theaters such as the Alhambra and the Lincoln. However, there were unwritten stipulations in which deductions were made for anything Schiffman chose, such as fees for the films shown before or after entertainers' acts.[24] The Lafayette survived through the 1960s, changing acts and types of entertainment to suit the respective eras.[25]

The site is currently under construction for a block-long apartment building complex between 132 and 131st Streets.

➤ Walk southward to the northeast corner of Adam Clayton Powell Jr. Boulevard and 131st Street to find Site 28.

Tour 2, Site 28
Connie's Inn

2221 Adam Clayton Powell Boulevard
(northeast corner of West 131st Street)

Connie's Inn (1921–1940) was a segregated venue that was one of the three large entertainment venues that featured full revues composed of a house orchestra, singers/dancers, and a comedian in the 1920s. The other large entertainment

FIGURE 28. Chorus girls and other performers, as well as a stage prop resembling a railroad passenger car, at Connie's Inn, ca. 1920s *(Photographs and Prints Division, Schomburg Center for Research in Black Culture, The New York Public Library, Astor, Lenox and Tilden Foundations)*

venues were Smalls Paradise and the Cotton Club. Allie Ross's Orchestra was at Connie's Inn from 1926 to 1929, when it was replaced by the Carroll Dickerson Orchestra including Louis Armstrong on trumpet.

The site is currently under construction for a block-long apartment building complex between 132 and 131st Streets.

➤ Look to the center of the intersection of Adam Clayton Powell Jr. Boulevard and 131st Street. The small statue on the north side of the intersection is Site 29.

Tour 2, Site 29
Tree of Hope

Center of the intersection of Adam Clayton Powell Jr. Boulevard and West 131st Street

Harlem's "Blarney Stone" was once the stump of a large elm located at this intersection. Gamblers would touch the tree for good luck on their way to card or dice games. Musicians would touch it on their way to auditions. After a car hit the stub, a small statue was installed where the

FIGURE 29. Small statue replacing the Tree of Hope (*K. Taborn, 2017*)

tree used to stand at the center of the intersection. Today, the Apollo Theater exhibits a replica of the original "Tree of Hope" stump, where visitors and Apollo performers can continue the tradition, wishing for good luck on their way to fame and fortune.

➤ This concludes Tour 2. To return to the 2 or 3 subway lines, walk northward to 135th Street and eastward to Malcolm X Boulevard.

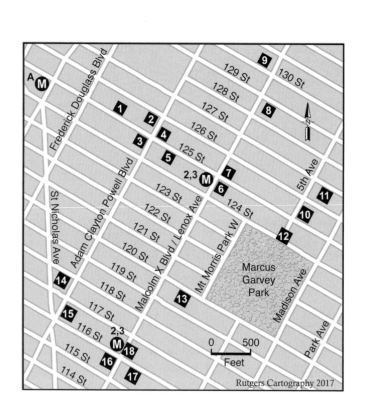

A**M**

129 St

130 St

9

Frederick Douglass Blvd

128 St

127 St

8

1

2

126 St

4

3

125 St

5

5th Ave

2,3 **M** 7

6

11

123 St

124 St

10

122 St

12

St Nicholas Ave

Adam Clayton Powell Blvd

121 St

Mt Morris Park W

120 St

119 St

Marcus
Garvey
Park

14

118 St

Malcolm X Blvd / Lenox Ave

13

15

117 St

Madison Ave

116 St

2,3 **M** 18

Park Ave

115 St

16

0 500

114 St

17

Feet

Rutgers Cartography 2017

Tour 3

Central Harlem: South

Estimated duration: 2 to 2½ hours

1. Apollo Theater
2. Alhambra Ballroom
3. Theresa Hotel
4. Adam Clayton Powell Jr. State Office Building and Statue
5. Studio Museum of Harlem
6. Harlem Community Art Center
7. Subway Mosaics by Faith Ringgold
8. National Jazz Museum
9. New Amsterdam Musical Association
10. National Black Theatre
11. Langston Hughes House / i, too arts collective
12. Mount Morris Historical District
13. Maya Angelou Residence
14. Minton's Playhouse
15. Graham Court
16. Masjid Malcolm Shabazz / Nation of Islam Temple No. 7
17. Malcolm Shabazz Harlem Market
18. Subway Mosaics by Vincent Smith

➤ Take the A, B, C, or D train to the 125th Street station and then walk eastward one and a half blocks on the north side of 125th Street to find Site 1.

Tour 3, Site 1
Apollo Theater

253 West 125th Street (north side of the street)

In 1934, Frank Schiffman, a Jewish entrepreneur who had owned and successfully managed the Lafayette Theatre, bought and began booking swing bands into the Apollo Theater at 253 West 125th Street. Under Schiffman's management, the Apollo became one of the leading entertainment centers in Harlem.

The theater presented all of the major entertainers who played in Harlem's theaters, ballrooms, and clubs. A competition among performers was established at the Wednesday amateur nights, with the winning act determined at the end of the show by the amount of applause elicited, as the master of ceremonies placed a hand over each performer's head. Often, the audience was overcome with the urge to judge an act before the end of the performance, and there began to be a regular interaction between audiences and performers. Performers knew that Apollo audiences were the toughest and most sophisticated yet also the most rewarding to play before. Amateur nights became so popular that there was usually a three- to four-month wait to get on the bill. Through the years, amateur nights at the Apollo were responsible for launching the careers of Sarah Vaughan, Pearl Bailey, James Brown, Ruth Brown, and Gladys Knight. The Apollo also nurtured the careers of

FIGURE 30. The Apollo Theater, ca. 1946–1948 *(William P. Gottlieb / Ira and Leonore S. Gershwin Fund Collection, Music Division, Library of Congress)*

singers such as Billie Holiday, Ella Fitzgerald, and comedians "Pigmeat" Markham, Jackie "Moms" Mabley, and Dusty Fletcher.[1]

Following the theater's heyday, its interior received landmark status in 1983 to retain its original internal architectural design. Since 1991, the theater has been owned and operated by the Apollo Theater Foundation.

Ongoing programming includes performances by nationally and internationally recognized entertainers, community outreach and educational programs, and the famed Wednesday-night amateur contests.

► Walk eastward on 125th Street half a block to Adam Clayton Powell Jr. Boulevard (Seventh Avenue). Turn left (north) and walk to the end of the block. On the southwest corner of 126th Street is Site 2.

Tour 3, Site 2
Alhambra Ballroom

2110 Adam Clayton Powell Jr. Boulevard
(southwest corner of West 126th Street)

During the mid-1920s, the Alhambra Ballroom (aka Alhambra Theatre) was presenting Black entertainment stars; however, seating was segregated, with Blacks only allowed to sit in the balcony. Florence Mills performed in the musical revue *The Blackbirds* here in 1926. A following show featured Bill "Bojangles" Robinson. The theater had a regular chorus line of female singers and dancers who would perform thirty minutes of chorus work and thirty minutes of drama. Playing at the Alhambra had a price, though. Frank Schiffman (the owner and operator of the Lafayette Theatre and later the Apollo Theater) dominated

bookings of theatrical entertainment in Harlem during the time. Schiffman ruled with an iron fist, and it was known that if you worked at the Alhambra, you could not work at Schiffman's theaters.[2]

The building continues to carry the same name and is rented out for banquets.

➤ Walk back southward on Adam Clayton Powell Jr. Boulevard to 125th Street. The large white building on the southwest corner is Site 3.

Tour 3, Site 3
Theresa Hotel

2082–2096 Adam Clayton Powell Jr. Boulevard
(southwest corner of 125th Street; now Theresa Towers)

Alternatively known as the "Uptown Waldorf," the Theresa Hotel was built in 1913. The three-hundred-room building is adorned with a white terra-cotta façade. It was segregated, with a whites-only policy until 1940. Following desegregation, famous personalities staying at the hotel over the years include heavyweight boxer Joe Louis, who was a frequent guest during the 1940s. Louis attracted huge crowds outside the hotel after his fights against Max Schmeling and others. Political and social activist Asa Philip Randolph established offices here in 1941 to organize for the March on Washington that led President

FIGURE 31. Theresa Towers (*K. Taborn, 2017*)

Franklin D. Roosevelt to ban the exclusion of Blacks from federal contracts during World War II. Malcolm X rented offices here for his Organization for African Unity in the early 1960s, and Fidel Castro and his staff stayed here in 1960 when he came to New York to address the United Nations. In 1971, the hotel was converted for business-office rentals and renamed Theresa Towers.

➤ Look across the street to the northeast corner of Adam Clayton Powell Jr. Boulevard and 125th Street to find Site 4.

Tour 3, Site 4
Adam Clayton Powell Jr. State
Office Building and Statue

163 West 125th Street
(northeast corner of Adam Clayton Powell Jr. Boulevard)

Completed in 1973 by the African American Ifill John-
son architectural firm, the Adam Clayton Powell Jr. State
Office Building is Harlem's only skyscraper. It was orig-
inally named the Harlem State Office Building but was
renamed to honor Harlem's first Black congressman, Adam
Clayton Powell Jr., in 1983. The Powell statue in front was
created by sculpture Raoul Cadet and completed in 2005.

*To read more about Adam Clayton Powell Jr., civil rights, and
social justice movements, see page 151.*

FIGURE 32. Adam Clay-
ton Powell Jr. statue
in front of the Adam
Clayton Powell Jr.
State Office Building,
125th Street *(K. Taborn,
2017)*

➤ Walk eastward on the south side of 125th Street a few doors down the block to find Site 5.

Tour 3, Site 5
Studio Museum of Harlem

144 West 125th Street (south side of street)

Founded in 1968, the Studio Museum of Harlem moved to its present address in 1979. This internationally recognized museum for African American art includes a collection of works by historically significant and present-day artists of African descent. The museum is an artistic stronghold in the Harlem community, featuring ongoing exhibits, educational programs, and an artist-in-residence program. The museum is open Thursdays and Fridays, 12 p.m. to 9 p.m.; Saturdays and Sundays, 12 p.m. to 6 p.m.; on Sundays, entry is free of charge.

To read about the 1930s Harlem Arts Movement, see page 158.

➤ Continue walking eastward to Malcolm X Boulevard (Lenox Avenue). On the southeast corner is Site 6.

Tour 3, Site 6
Harlem Community Art Center

290 Malcolm X Boulevard (southeast corner of 125th Street)

This was the location of the Harlem Community Arts Center from 1937 to 1942. Political and social consciousness raising began in the Harlem arts community in the 1920s, and by the 1930s, a Harlem Arts Movement was established, culminating in the eventual creation of the Harlem Community Art Center in 1937. The Uptown Art Laboratory workshop at the Harlem Artists Guild was moved to the Harlem Music-Art Center on 123rd Street and Mount Morris Park West and, still later, in 1937, to the Harlem Community Art Center here. The center was celebrated broadly as a success story for the tens of thousands of students who attended classes in drawing, painting, sculpture, printmaking, graphic design, costume design, and weaving. Popular lectures, art exhibits, and demonstrations were offered. In a 1938 report for the Federal Arts Program, the acting director of the center, Gwendolyn Bennett, stated,

> [The Harlem Community Art Center] was a dream when Negro artists forming the Harlem Artists' Guild . . . met to pool their experiences in a discussion of ways to bring about the establishment of a permanent art center for Harlem. . . . When classes were organized by the WPA/FAP, first in a renovated garage known as the Uptown Art Laboratory, and later in the Music-Art Center, this dream began to

take shape. Working closely with Augusta Savage, who was in charge of both of these ventures, I began to see an ideal acquire bone and sinew. The establishment of the Harlem Community Art Center in a large empty loft at the corner of 125th Street and Lenox Avenue began to symbolize the growth and maturity of this ideal. The coming of eager children to register in the classes, the formation of a sponsoring committee, the long line of visitors from Harlem and from the rest of the country, and the growing enthusiasm among the people who worked in the Center acted like a strong tonic on the entire community.[3]

The Harlem Community Art Center became a leading site of African American art in Harlem and a source of racial pride throughout the United States. The building is

FIGURE 33. Augusta Savage, ca. 1930 (Photographs and Prints Division, Schomburg Center for Research in Black Culture, The New York Public Library, Astor, Lenox and Tilden Foundations)

RECOMMENDED EATERIES

Several fine restaurants are located here, including the following:

The Red Rooster
310 Malcolm X Boulevard between 125th and 126th Streets

Corner Social
321 Malcolm X Boulevard

Whole Foods Market and Cafeteria
100 West 125th Street

Harlem Shake
100 West 124th Street

Chez Lucienne French Bistro
308 Malcolm X Boulevard

rented out for offices today. The center was located above what is now Cohen's Fashion Optical store.

To read more about the 1930s Harlem Arts Movement, see page 158.

➤ At the intersection, enter the 125th Street subway station (2 and 3 trains) and proceed to either the uptown or downtown platform (you will need to pay the subway entrance fee) to find Site 7.

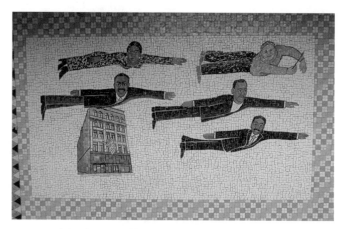

FIGURE 34. A Faith Ringgold mosaic at the 125th Street subway station (*K. Taborn, 2017*)

Tour 3, Site 7
Subway Mosaics by Faith Ringgold

125th Street subway station

Faith Ringgold's artistic creations of paintings, "story quilts," soft clothe sculptors, children's storybooks, and mosaic tiles are marvelous, visionary gems. In her New York City subway mosaics, titled *Flying Home Harlem Heroes and Heroines*, the Sugar Hill native draws on her reoccurring artistic theme: "Anyone can fly. . . . All you have to do is try!"

➤ Exit the subway station and walk northward on Malcolm X Boulevard to 129th Street. Turn right (east) to find Site 8, on the south side of the street.

Tour 3, Site 8
National Jazz Museum

58 West 129th Street (south side of street)

The National Jazz Museum opened in the late 1990s and moved to its current location in 2016. A treasure of jazz, positioned to carry the cultural legacy of jazz in Harlem into the twenty-first century, the museum presents live performances, talks, and exhibits and houses historical live recordings. The artistic directors are noted jazz musicians Christian McBride and Jonathan Batiste, and the Board of Directors includes Wynton Marsalis, Ken Burns, and Kenneth McIntyre.

FIGURE 35. The National Jazz Museum in Harlem, flag (*K. Taborn, 2017*)

- Walk westward back to Malcolm X Boulevard and turn right (north) to 130th Street, then turn left (west) to find Site 9, on the north side of the street.

Tour 3, Site 9
New Amsterdam Musical Association

107 West 130th Street (north side of street)

This is the oldest Black American musical association continuing in operation today. When it was first incorporated in 1905, it provided employment opportunities and a place for affiliation between Black musicians who were locked out of segregated, white music unions. Some of the early gigs at which association members were employed to play were Booker T. Washington's Sixth Annual National Negro Business League in 1905, with the comedy team of Williams and Walker also on the program, and a 1913 "Emancipation Exposition" with art exhibits exemplifying the "progress of the race." The association purchased the building and currently operates a Monday-night jazz jam session.[4]

To read more about vaudeville theater and minstrelsy, see page 167.

► Walk back eastward to Malcolm X Boulevard, turn right (south), and walk back down to 125th Street. Turn left (east) and walk to Fifth Avenue. Turn left (north) to find Site 10, on the east side of the street.

Tour 3, Site 10
National Black Theatre

2031 Fifth Avenue (east side of street)

The great visionary artist and entrepreneur Barbara Teer founded the National Black Theatre (NBT) in 1968 to provide a safe space for Black artists to express themselves on their own terms within an authentically African and African American domain. The theater has produced over three hundred original theatrical works since its inception. Teer commissioned Haitian American architect Gerard Paul for the building's design, and she installed New Sacred Nigerian artwork throughout the theater and incorporated it within the building's structure. (See the home of Barbara Teer and her family in Tour 1, Site 11.)

Today, the NBT lives on as a safe, creative space for actors (young and old) to realize their highest potential, a shrine to powerful African and African American ancestors (Teer included), and a vivid, "living museum" of African art. Enter the building and inquire about current productions to gain a fuller experience of this living monument to Black culture.

► Continue walking northward on Fifth Avenue to 127th Street and turn right (eastward) to find Site 11, on the south side of the street.

Tour 3, Site 11
Langston Hughes House / i, too arts collective

20 East 127th Street / Langston Hughes Place
(south side of street)

By the time Langston Hughes bought this brownstone in 1947, he was a post–Harlem Renaissance elder and a renowned author. He lived here on the top floor, until his death eighteen years later in 1965. While living here, Hughes penned some of his most memorable writings including *Simple Speaks His Mind*, *The First Book of Negroes*, and *Montage of a Dream Deferred*. In 1982, the Langston Hughes House was entered into the National Registry of Historic Places.[5] In 2016, a collective of writers and artists leased the Hughes House and opened the i, too arts collective here. Visit the collective's website to learn about ongoing programming: www.itooarts.com.

To read more about Langston Hughes, the New Negro Movement, and "Niggerati Manor," see page 161.

FIGURES 36 & 37.
Above: Langston Hughes Place street sign *(K. Taborn, 2017)*

Left: Langston Hughes House *(K. Taborn, 2017)*

- Walk back westward to Fifth Avenue and turn left (south). Continue walking one block south of 125th Street to Marcus Garvey Park to find Site 12.

Tour 3, Site 12
Mount Morris Historical District

The north-to-south borders of the Mount Morris Historical District are roughly between West 124th and West 118th Streets; the west-to-east borders are roughly between Adam Clayton Powell Jr. Boulevard and Mount Morris Park West[6]

This is the Harlem neighborhood of Mount Morris Park, with beautiful nineteenth- to twentieth-century, Gilded Age residential and church architecture, preserved since

FIGURE 38. Mount Morris residences (*K. Taborn, 2017*)

1971 as a Historic District by New York City's Landmarks and Preservation Committee. The park (formerly Mount Morris Park) was renamed in honor of pan-Africanist Marcus Garvey in 1973.

➤ On 124th Street, walk westward to the west end of the park (Mount Morris Park West) and then turn left (south), walking along Mount Morris Park West to 120th Street. Turn right (west) and walk on the south side of the street to find Site 13.

Tour 3, Site 13
Maya Angelou Residence

58 West 120th Street (south side of street)

This building was a former home of Maya Angelou's. Angelou was a writer, an actress, and a dancer, but it was her candor and beauty as a writer that drew to her a devoted and internationally affectionate following. From her debut autobiography, *I Know Why the Caged Bird Sings*, to her womanist poetry, Angelou defiantly spoke back to a world

FIGURE 39. Maya Angelou home (*K. Taborn, 2017*)

that would have silenced or minimized her. In 2004, Angelou bought this four-floor brownstone building, and it was here that she recorded her radio talk show on the Oprah (Winfrey) and Friends channel. This was also the site for some of Angelou's famous New Year's Day festivities, which ran into the wee hours of the night.

➤ Continue walking westward on 120th Street, across Malcolm X Boulevard, to Adam Clayton Powell Jr. Boulevard. Turn left (south), walk to 118th Street, and turn right (west) to find Site 14, on the south side of the street.

Tour 3, Site 14
Minton's Playhouse

206 West 118th Street (south side of street)

Near the end of the block on the south side of the street is Minton's Playhouse. Minton's was a hotbed for the development of bebop (jazz) in the 1940s. Drummer Kenny Clarke led the house band, with Thelonious Monk on piano, Joe Guy on trumpet, and Nick Fenton on bass. The Monday-night jam sessions became a workshop in bebop experimentation frequented by Dizzy Gillespie, Charlie Christian, Thelonious Monk, Art Blakey, Mary Lou Williams, and other leaders of the bebop movement.

Trumpeter Miles Davis, who moved to New York in 1944, recalled,

> Minton's and [next door] the Cecil Hotel were both first-class places with a lot of style. The people that went there were the cream of the crop of Harlem's black society.... People who came to Minton's wore suits and ties because they were copying the way people like [band leaders] Duke Ellington or Jimmie Lunceford dressed.... But to get into Minton's didn't cost anything. It cost something like two dollars if you sat at one of the tables, which had white linen tablecloths on them and flowers in little glass vases.... You came uptown to Minton's if you wanted to make a reputation among musicians. Minton's ... taught a whole lot of musicians, made them what they eventually became.[7]

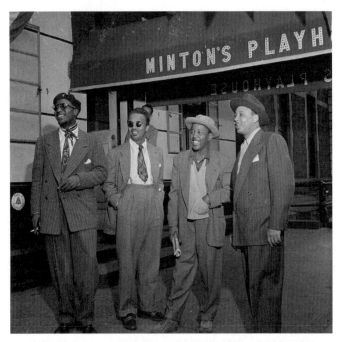

FIGURE 40. Thelonious Monk, Howard McGhee, Roy Eldridge, and Teddy Hill, at Minton's Playhouse, 1947 (*William P. Gottlieb / Ira and Leonore S. Gershwin Fund Collection, Music Division, Library of Congress*)

Minton's was reopened by businessman Richard Parsons in 2013. The restaurant and jazz club features top-of-the-line jazz entertainment with dinner and brunch menus.

To read more about the development of bebop (jazz) in Harlem, see page 171.

▶ Walk back eastward to Adam Clayton Powell Jr. Boulevard and turn right (south) to find Site 15, on the east side of the street between 116th and 117th Streets.

Tour 3, Site 15
Graham Court

1925 Adam Clayton Powell Jr. Boulevard (east side of street)

William Waldorf Astor built this apartment complex in 1898. The block-long building was constructed in the Italian palazzo style with (today) ninety-four apartments facing inward toward a central courtyard. The brilliant Harlem Renaissance writer and folklorist Zora Neale Hurston

FIGURE 41. Graham Court (*K. Taborn, 2017*)

lived here around 1935.[8] The building was landmarked in 1984. This site continues to be used for rented residences.

➤ Walk southward on Adam Clayton Powell Jr. Boulevard to 116th Street and turn left (east), walking to Malcolm X Boulevard. On the southwest corner is Site 16.

Tour 3, Site 16
Masjid Malcolm Shabazz / Nation of Islam Temple No. 7

102 West 116th Street
(southwest corner of Malcolm X Boulevard)

Malcolm X was appointed the chief minister at Temple No. 7, where he served as the Nation of Islam's most powerful and charismatic speaker from 1954 to 1964. It was

RECOMMENDED EATERIES

Amy Ruth's
113 West 116th Street
Serves soul food cuisine, breakfast, lunch, and dinner

Mist Harlem
46 West 116th Street
A Caribbean-themed eatery that serves coffee, tea, wine, beer, and snacks to full meals

FIGURE 42. The former site of Nation of Islam Temple No. 7 (*K. Taborn, 2017*)

while ministering at a storefront at this location that Malcolm X began to build his impressive following of Black Muslim devotees and among the general African American public. No longer a Nation of Islam mosque, the Masjid Malcolm Shabazz today serves Sunni Muslims of African American and Senegalese descent. The original temple was replaced by the current building, named Masjid Malcolm Shabazz in 1976 to honor Malcolm X.[9]

To read more about Malcolm X, see page 179.

➤ Cross Malcolm X Boulevard and walk eastward on the south side of 116th Street a few doors down to find Site 17.

Tour 3, Site 17
Malcolm Shabazz Harlem Market

West 116th Street, between Malcolm X Boulevard
and Fifth Avenue (south side of street)

This outdoor market features African vendors and African crafts. It is open daily from 10 a.m. to 8 p.m.

FIGURE 43. Malcolm Shabazz Harlem Market (*K. Taborn, 2017*)

- Walk back westward to Malcolm X Boulevard and enter the 116th Street subway station to find Site 18.

Tour 3, Site 18
Subway Mosaics by Vincent Smith

116th Street

In the 116th Street subway station, see the mosaics titled *Minton's Playhouse: Movers and Shakers,* by Brooklyn-raised artist Vincent Smith.

- This concludes Tour 3.

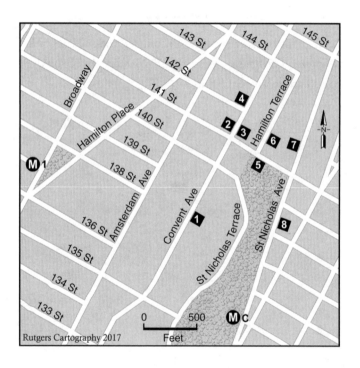

Tour 4

West Harlem: North

Estimated duration: 1½ hours

1. City College of New York
2. John Henrik Clarke House
3. Alexander Hamilton Statue
4. Hamilton Heights Buildings
5. Hamilton Grange
6. Apartment of Mary Lou Williams
7. Harlem School of the Arts
8. 580 St. Nicholas Avenue

► Take the 1 subway train to 137th Street, walk one block north on Broadway to 138th Street, and turn right (east). Walk two blocks to the entrance of the City College of New York (CCNY) at Amsterdam Avenue. Keep walking eastward to Convent Avenue, where you will see the old campus with neo-Gothic architecture.

Tour 4, Site 1
City College of New York

Between 133rd and 140th Streets and
Amsterdam Avenue and St. Nicholas Park

The City College of New York was created in the mid-nineteenth century to meet the needs of economically challenged but academically prepared college students. At

a time when private colleges in New York were exclusively limited to privileged students, CCNY admitted working- to middle-class Euro-American and Jewish immigrants free of charge. The original campus buildings were built in 1907 and designed by George Browne Post. The school remained primarily white, however, until the mid-1960s when Black, Latino, and Asian students began to attend under "open admission." Today, CCNY is ethnically diverse, and although it is no longer tuition free, it is an affordable option for higher education in New York City.

FIGURE 44. City College of New York, old campus building (*K. Taborn,* *2017*)

► Turn left (north) on Convent Avenue and continue walking northward across 141st Street, on the west side of the street, to find Site 2.

Tour 4, Site 2
John Henrik Clarke House

286 Convent Avenue (west side of street)

This building is named in honor of John Henrik Clarke—a noted intellectual, author, and educator from the late 1940s until his death in 1998. Clarke wrote, edited, and contributed to numerous books and articles on Black history, and he was a leader in the establishment of post-civil-rights-era Black Studies academic programs, such as Hunter College's Black and Puerto Rican Studies Program in 1969. He

FIGURE 45. Plaque outside the Clarke House (*K. Taborn, 2017*)

was also instrumental in the establishment of Cornell University's Africana Studies and Research Program, and he founded the African Heritage Studies Association in 1968. The Clarke House is owned and operated by the Board for the Education of People of African Ancestry—an organization of individuals "with proven records of community service and leadership" in the Harlem and African American community. Programs run by the board have included "The Institute for Kinship Foster Parents," "In Defense of Our Children," and "Sitting at the Feet of the Masters."

➤ Directly across the street from the Clarke House is Site 3.

Tour 4, Site 3
Alexander Hamilton Statue

287 Convent Avenue (east side of street)

This was the second location for the home of Alexander Hamilton, the first secretary of the U.S. Treasury and one of the Founding Fathers of the U.S. Constitution. The home, known as Hamilton Grange, was relocated to this site around 1889 to 2008, when it was managed by the adjacent St. Luke's Episcopal Church. Hamilton's statue remains here at the Grange's second site today. Hamilton originally built the Grange two blocks north, at what is now the southwest corner of 143rd Street and Convent Avenue, along a rustic New York countryside in 1802. The

FIGURE 46. Alexander Hamilton statue (*K. Taborn, 2017*)

Hamilton family lived at the original Grange location for the final two years of Alexander's life. The Grange was moved one more time in 2008, to 141st Street east of Convent Avenue, where it rests today (see Site 5 of this tour).

➤ Continue walking northward a couple of blocks up on Convent Avenue to find Site 4.

Tour 4, Site 4
Hamilton Heights Buildings

Convent Avenue between West 141st and 144th Streets

This is the center of the Hamilton Heights area of Harlem, which branches out onto side streets along Convent Avenue, with striking residential low-rise architectural buildings built between 1886 and 1902.

➤ Walk back southward to 141st Street and turn left (east) to find Site 5, on the south side of the street.

Tour 4, Site 5
Hamilton Grange

414 West 141st Street (south side of street)

The current location of the Grange was reopened to the public in 2011 and is now maintained by the National Parks

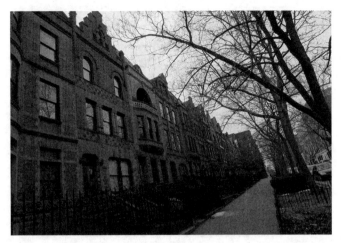

FIGURE 47. Private residences on Convent Avenue (*K. Taborn, 2017*)

FIGURE 48. Hamilton Grange (*K. Taborn, 2017*)

Service as a museum and a monument to Alexander Hamilton. Operating hours are Wednesdays through Sundays, 9 a.m. to 5 p.m., except Thanksgiving Day and Christmas Day. Admission is free of charge.

➤ Directly across the street from Hamilton Grange, walk onto Hamilton Terrace to find Site 6.

Tour 4, Site 6
Apartment of Mary Lou Williams

21 Hamilton Terrace (east side of street)

Pianist Mary Lou Williams was a master of jazz genres, from stride piano to swing-band piano playing and arranging and composing from the blues to bebop. With a foundation in diverse piano styles, Williams earned the position of arranger for one of the most popular Kansas City swing-band orchestras during the 1930s: Andy Kirk and His Twelve Clouds of Joy. After moving to New York City in 1941, Williams's apartment at 21 Hamilton Terrace became a frequent meeting place for bebop players, and Williams would informally instruct younger masters on playing the music. According to Williams,

> All during this time, my house was kind of a headquarters for young musicians. Tadd Dameron would come to write

FIGURES 49 & 50.
Above: At Mary Lou Williams's apartment, 1947: Jack Teagarden, Dixie Bailey, Williams, Tadd Dameron, Hank Jones, Dizzy Gillespie, and Milt Orent *(William P. Gottlieb / Ira and Leonore S. Gershwin Fund Collection, Music Division, Library of Congress)*

Left: Mary Lou Williams's apartment *(K. Taborn, 2017)*

when he was out of inspiration, and Monk did several of his pieces there. Bud Powell's brother, Richie, who also played piano, learned how to improvise at my house and everybody came or called for advice. Charlie Parker would ask what did I think about him putting a group of strings together, or Miles Davis would ask about his group with the tuba, the one that had John Lewis and Gerry Mulligan and Max Roach and J.J. Johnson.[1]

This site continues to be a private residential building.

To read more about the development of bebop (jazz) in Harlem, see page 171.

➤ Walk back southward to 141st Street and turn left (east). Walk to St. Nicholas Avenue and turn left (north) to find Site 7, on the west side of the street.

Tour 4, Site 7
Harlem School of the Arts

645 St. Nicholas Avenue (west side of street)

In 1947, African American opera singer Dorothy Maynor established the St. James Community Center in the basement of the adjacent St. James Presbyterian Church. The center eventually was renamed the Harlem School of the

Arts, and the ground-breaking for the current building (just north of the church) was in 1975. Serving Harlem's children from two to eighteen years of age in the performing and visual arts in Western and African American art traditions, the Harlem School of the Arts brings together noted New York artists and Harlem youth to provide students with vigorous training and to build their self-confidence and to realize beauty in their lives.

To read more about the 1930s Harlem Arts Movement, see page 158.

➤ Walk southward on St. Nicholas Avenue to find Site 8, on the east side of the street between 139th and 140th Streets.

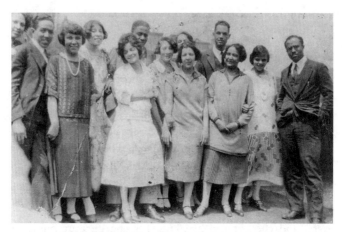

FIGURE 51. Guests at a breakfast party for Langston Hughes hosted by Regina Anderson (Andrews) and Ethel Ray at 580 St. Nicholas Avenue, Harlem, May 1925: *back row, left to right*: Ethel Ray (Nance), Langston Hughes, Helen Lanning, Pearl Fisher, Rudolf Fisher, Luella Tucker, Clarissa Scott, Hubert Delany; *front row, left to right*: Regina Anderson (Andrews), Esther Popel, Jessie Fauset, Marie Johnson, and E. Franklin Frazier *(Photographs and Prints Division, Schomburg Center for Research in Black Culture, The New York Public Library, Astor, Lenox and Tilden Foundations)*

Tour 4, Site 8
580 St. Nicholas Avenue

Between West 139th and 140th Streets (east side of street)

During the height of the Harlem Renaissance, in the 1920s, important literary figures frequented the apartment of librarians Regina Anderson and Ethel Nance at 580 St. Nicholas Avenue. Anderson and Nance worked at the

Walking Harlem

135th Street branch of the New York Public Library (the early Schomburg Library; see Tours 1 and 2). The photograph in figure 51, taken in 1925 during festivities in honor of Langston Hughes, conveys the joyous atmosphere and the camaraderie that prevailed among the Harlem literati at the apartment gatherings.

➤ This concludes Tour 4. Continue walking southward on St. Nicholas Avenue to the C train at 135th Street (entrances between 137th Street and 135th Street).

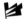

A,C,1 Ⓜ Ⓜ

168 St

St Nicholas
Avenue

166 St

11

164 St

162 St

Broadway

160 St

Edgecombe Ave

9

10

Jumel
Terrace

158 St

Amsterdam Ave

8

Sylvan
Terrrace

156 St

6 **7**

152 St

5

150 St

St Nicholas Ave

St Nicholas Pl

4

Edgecombe Ave

148 St

3

0 500

Harlem River

146 St

2
1

subway at
↓ 145th St

Feet

Rutgers Cartography 2017

Tour 5

West Harlem, Washington Heights: Far North

Estimated duration: 1½ hours

1. Jimmy's Chicken Shack
2. St. Nick's Pub / Various Nightclubs at 773 St. Nicholas Avenue
3. Bailey's Castle
4. 409 Edgecombe Avenue
5. Sugar Hill Children's Museum
6. Duke Ellington Apartment
7. Victor Hugo Green Apartment
8. 555 Edgecombe Avenue
9. Sylvan Terrace
10. Morris-Jumel Mansion
11. Malcolm X and Dr. Betty Shabazz Memorial and Educational Center

From the 145th Street station (A, B, C, or D trains), walk northward on St. Nicholas Avenue to find Site 1, on the west side of the street between 148th and 149th Streets.

Tour 5, Site 1
Jimmy's Chicken Shack

763 St. Nicholas Avenue (west side of street)

Jimmy's Chicken Shack was a popular eatery that employed Malcolm X (then known as "Detroit Red") as a waiter, who worked alongside Chicago Red (later known as the comedian Redd Foxx) as a dishwasher in the 1940s. Malcolm recalled that Redd Foxx kept everyone "in stitches" while working. Bebop saxophonist Charlie Parker was also said to work here in the 1930s. The *Amsterdam News* reported that around 1942, the club was a cozy and intimate room located in the basement of the building, with the walls decorated with pictures of outstanding Black celebrities. The attraction was more than the chicken though. Jimmy's was "the place to see and be seen." Hollywood film stars Lana Turner, Isabel Jewel, Luise Rainer, and the Dandridge sisters were some of the regular celebrities included among the guests.

The site is currently the Tsion Café.

RECOMMENDED EATERY

Tsion Café
763 St. Nicholas Avenue, between 148th and 149th Streets
Serves Ethiopian and Mediterranean cuisine and refreshments

OFF-TOUR SITE

Dunbar Apartments, 246 West 150th Street. East of Jackie Robinson Park, between Frederick Douglass and Adam Clayton Powell Jr. Boulevards, is the Dunbar Apartments complex. Six buildings with six floors apiece were completed in 1928. At the height of segregation for Blacks, during the late 1920s–1930s, the residents included several noted Harlemites, including W. E. B. Du Bois, Paul Robeson, Asa Philip Randolph, Countee Cullen, Bill "Bojangles" Robinson, Fletcher Henderson (orchestral leader), and Matthew Henson (African American explorer and among the first men to reach the North Pole).[1]

➤ Continue walking northward a few doors up on the west side of St. Nicholas Avenue to find Site 2.

Tour 5, Site 2

St. Nick's Pub / Various Nightclubs at 773 St. Nicholas Avenue

Southwest corner of 149th Street and St. Nicholas Avenue

773 St. Nicholas Avenue has been called the location for the longest-running series of nightclubs in Harlem. In the 1930s, it was the Poosepahtuck Club, featuring club events such as the 1934 Tuskegee Alumni Association's

"Hurdy Gurdy" dance that benefited the Urban League. The Poosepahtuck Club featured an outdoor garden, and musical entertainment was regularly provided by pianist Joe Jordan and cabaret singer Monette Moore, a Broadway understudy for Ethel Waters. In the late 1930s, the club was known as the Bowman Grill, and in the early 1940s, it was called the Moonlight Bar and Grill. From 1943 to 1950, the club was run by stride piano master Luckey Roberts, who renamed it Luckey's Rendezvous. Entertainment at Luckey's included Roberts himself on piano, singer and actress Claudia McNeil, and jazz pianists Donald Lambert, Marlow Morris, and Art Tatum.

FIGURE 52. Art Tatum, 1946 *(Courtesy William P. Gottlieb / Ira and Leonore S. Gershwin Fund Collection, Music Division, Library of Congress)*

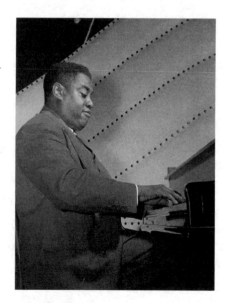

In 1950, the club was renamed the Pink Angel, and it continued to feature jazz seven nights a week.[2] In the early 1960s, the venue became St. Nick's Pub. (You can still see the weathered marquee at the entrance of the former pub.) The pub continued to feature jazz seven nights a week, with a popular following for its Monday-night jam sessions, and it featured African music on Saturdays. Established as a "must visit" for New York jazz musicians until its closing in 2011, celebrities such as Sarah Vaughan, Wynton Marsalis, Olu Dara, and Frank Lacy were some of the club patrons.

▶ From the intersection of 149th Street and St. Nicholas Avenue, walk eastward to cross St. Nicholas Avenue and then take an immediate left to walk up St. Nicholas Place. Look to the northeast corner of St. Nicholas Place and 150th Street to find Site 3.

Tour 5, Site 3
Bailey's Castle

10 St. Nicholas Place (northeast corner of St. Nicholas Place)

Bailey's Castle was built between 1886 and 1888 by James Bailey of Barnum and Bailey Circus fame. At the time, circuses were a major form of American entertainment, and Bailey was referred to as the best circus organizer in the business. The building became a funeral home in the 1950s and was designated a National Historic Landmark in 1974. Today, the castle is a privately owned property.

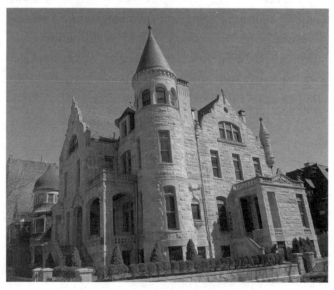

FIGURE 53. Bailey's Castle on Sugar Hill (*K. Taborn, 2017*)

OFF-TOUR SITE

Dance Theatre of Harlem, 466 West 152nd Street. For over four decades, the Dance Theatre of Harlem has provided dance performances and classes. Founded in 1969 by ballet masters Karel Shook and Arthur Miller, the Dance Theatre provides education in ballet and other dance genres for preschoolers through professional and advanced training for adults. The Dance Theatre houses an internationally renowned troupe that features ballet classics as well as contemporary performances that celebrate African American culture.

► Continue walking northward on St. Nicholas Place and, immediately before the intersection with 155th Street, make a right onto Edgecombe Avenue. The first apartment building to your right is Site 4.

Tour 5, Site 4
409 Edgecombe Avenue

In the late 1930s, this famous building began to attract various middle-class Sugar Hill residents of notoriety, including Thurgood Marshall (civil rights lawyer and U.S. Supreme Court justice), Ruth and Mercer Ellington (respectively, the sister and the musician son of Duke Ellington), Aaron Douglas (painter), Jules Bledsoe (actor), W. E. B. Du Bois,

Walter White and Roy Wilkins (NAACP officials), Madame Stephanie St. Claire (famed numbers runner), Barron D. Wilkins (nightclub proprietor), Jimmie Lunceford (big-band leader), Noble Sissle (vaudeville composer/lyricist), Jessie Fauset (writer), and Bruce Wright (New York Supreme Court judge).[3] Ongoing parties, soirees, and teas were held in the residents' apartments, and it was often the wives of noted male figures who hosted parties, keeping their friends of similar pedigree up-to-date on various happenings. One party from 1938, for example, was held in big-band leader Jimmie Lunceford's apartment, with Lunceford's wife hosting a "Mexican party." She served Mexican cuisine and donned a sombrero acquired during a recent trip to Mexico. Another party in 1938 was hosted by Aaron Douglas's wife, who featured internationally known African American choral arranger-director Hall Johnson.[4] The apartment of Walter White became known as the "White House" for the frequent social soirees attracting upscale celebrities and literary and political figures. A daughter of Walter White's recalled seeing writer and Harlem Renaissance aficionado Carl Van Vechten, American civil liberties lawyer Clarence Darrow, and writers Langston Hughes, Countee Cullen, and Claude McKay, among others, at her father's parties.[5] The residents in the building knew each other personally, and they created an African American community distinct from the hustling working class in the Central Harlem valley below.

FIGURE 54. 409 Edgecombe Avenue *(K. Taborn, 2017)*

The site is currently a privately owned cooperative building with individual family apartment units.

➤ Return to the intersection of St. Nicholas Place and 155th Street and walk westward one more block on 155th Street. On the southeast corner of St. Nicholas Avenue is Site 5.

<div align="center">

Tour 5, Site 5
Sugar Hill Children's Museum

</div>

<div align="center">

898 St. Nicholas Avenue (southeast corner of 155th Street)

</div>

The Sugar Hill Children's Museum is a recent development in the neighborhood, opening in 2016. Primarily

serving three- to eight-year-old children in the Sugar Hill area, the museum provides ongoing programming of art classes and storytelling to foster children's creativity, which leads to personal and academic success. The thirteen-story building, designed by renowned Tanzanian-British architect David Adjaye (who designed the National African American Museum in Washington, D.C.), also houses low-income and formerly homeless New Yorkers.

Admittance to the museum for children up to eight years of age is free. The museum is open Thursdays through Sundays, 10 a.m. to 5 p.m. Enter the building on St. Nicholas

FIGURE 55. The Children's Museum of Sugar Hill (*K. Taborn, 2017*)

Avenue to see innovative art exhibits and to find out about occasional musical performances for children and adults.

➤ Walk northward on St. Nicholas Avenue up to 157th Street. On the southwest corner is Site 6.

Tour 5, Site 6
Duke Ellington Apartment

935 St. Nicholas Avenue (southwest corner of 157th Street)

In 1923, Washington, D.C., native Edward Ellington moved to New York City to actively pursue his musical career. The twenty-four-year-old was already a fan of the stride-piano musical developments taking place in Harlem, and an important part of his move was to situate himself close to the stride masters, centered uptown. Early on, Ellington secured employment for his band, the Washingtonians, at Barron D. Wilkins's Exclusive Club in Harlem (see Tour 2, Site 15), and by 1928, Ellington was leading a popular

FIGURE 56. Duke Ellington residence, 935 St. Nicholas Avenue
(*K. Taborn, 2017*)

orchestra at the Cotton Club (see Tour 1, Site 24), with live radio broadcasts sweeping his name to national fame. Ellington went on to enjoy a fifty-year career, becoming a prolific composer and one of the most influential musicians of the twentieth century. Duke Ellington lived in apartment 4A of this building from 1939 to 1961. The apartment became a National Historic Landmark in 1976.

➤ Look across St. Nicholas Avenue to the southeast corner of the intersection to find Site 7.

Tour 5, Site 7
Victor Hugo Green Apartment

938 St. Nicholas Avenue (southeast corner of 157th Street)

Victor Hugo Green was a Black U.S. postal worker who published the *Green Book* travel guide for Black Americans from 1936 until 1964. During the height of segregation, the *Green Book* aided millions of Black travelers each year with its listings of Black-operated or Black-friendly businesses—restaurants, hotels, gas stations, resorts, hair dressers, and so on, spread throughout the U.S., Canada, Mexico, and Bermuda. The guide was an indispensible aid for Blacks when Jim Crow laws and segregation policies were normalized throughout the United States.

➤ Continue walking northward on St. Nicholas Avenue to 160th Street. Turn right (east) and walk to the intersection with Edgecombe Avenue to find Site 8.

Tour 5, Site 8
555 Edgecombe Avenue

160th Street and Edgecombe Avenue (southwest corner)

Perched on top of Sugar Hill, 555 Edgecombe looked down below at the Polo Grounds—the former New York Giants baseball park—to the east. As with 409 Edgecombe, 555

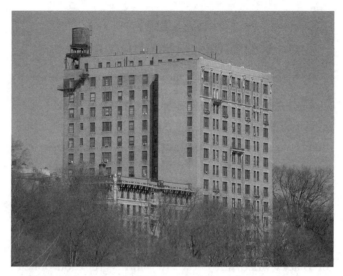

FIGURE 57. Looking up at 555 Edgecombe Avenue from 155th Street and St. Nicholas Place (*K. Taborn, 2017*)

housed a who's who of successful Harlemites. Particularly in the 1940s, several noted swing-band leaders—Count Basie, Andy Kirk, Don Redman, Erskine Hawkins, Benny Carter, and Cootie Williams—called 555 Edgecombe home. Their neighbors in the building included baritone-singer/actor and civil rights activist Paul Robeson (who shared two apartments with his wife), actor Canada Lee, singer/dancer and politician Bessie Buchanan, actor and activist Ossie Davis, and heavyweight boxing champion Joe Louis. Social gatherings and neighborliness among the residents were commonplace. For example, in 1941,

Paul Robeson's wife, Eslanda, hosted her bridge club, with whom she discussed her travels to Russia and the Far East. The same year, during Joe Louis's fight against Billy Conn at the Polo Grounds, Erskine Hawkins and his wife hosted members of Joe Louis's out-of-town family in their apartment.[6]

This site is currently a multifamily building with rental units. Longtime resident Marjorie Eliot, in apartment 3F, opens her home to visitors each Saturday and Sunday at 4 p.m. to attend a free jazz concert. Call 212-781-6595 to reserve a seat.

► Walk back westward on 160th Street for half a block and then turn right onto Jumel Terrace, walking onto the cobblestone street. The first street on the left is Site 9.

<div align="center">

Tour 5, Site 9

Sylvan Terrace

Between 160th and 162nd Streets

</div>

Twenty wood-frame homes on this short, cobblestone street date back to the late 1800s. They were originally built for middle-class residents including a feed dealer and a grocer.[7] The buildings are a rarity because of their survival for over a century. They were landmarked by the New York Landmarks Commission in 1970.

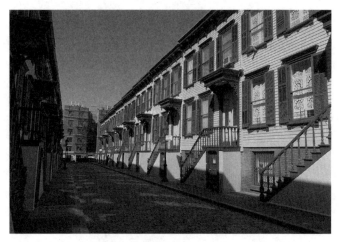

FIGURE 58. Sylvan Terrace *(K. Taborn, 2017)*

➤ Walk back eastward, directly across Jumel Terrace from Sylvan Terrace, to find Site 10.

Tour 5, Site 10
Morris-Jumel Mansion

65 Jumel Terrace

This is the oldest standing building in Manhattan. Built in 1765 as a summer home for Colonel Roger Morris and his wife, Mary Philipse, the villa was the center of a 130-acre estate, connecting the Hudson and Harlem Rivers. During the American Revolution, Morris and his wife were loyalists to the British, and they abandoned the villa to the

FIGURES 59 & 60. *Top*: Morris-Jumel Mansion, exterior *(Courtesy of Morris-Jumel Mansion; photo by K. Taborn, 2017)*; *Bottom*: Morris-Jumel Mansion, interior central room *(Courtesy of Morris-Jumel Mansion; photo by K. Taborn, 2017)*

American army. At that time, General George Washington occupied the villa for five weeks in 1776. Washington planned his first successful battle—the Battle of Harlem Heights—against the British here. Ten years after the Revolution, a white, former French-Haitian slaver, Steven Jumel, purchased the home.

Today Morris-Jumel Mansion Inc. operates the home as a museum. The home and museum were landmarked in 1970. Hours of the museum are Tuesdays through Sundays, 10 a.m. to 4 p.m. Admission to the main floor with a bookstore is free.

➤ Return to Jumel Terrace and walk northward to 162nd Street, turn left (west), and then walk westward across Amsterdam Avenue. Walk up St. Nicholas Avenue to 165th Street, turn left (west), and then walk one short block to Broadway. Turn right (north) on Broadway to find Site 11, on the northeast corner of 165th Street.

Tour 5, Site 11
Malcolm X and Dr. Betty Shabazz Memorial and Educational Center

3940 Broadway (northeast corner of West 165th Street)

Malcolm X delivered his final speech and was assassinated at this site on February 21, 1965. Following his death, the Harlem community rallied behind Malcolm's widow, Betty

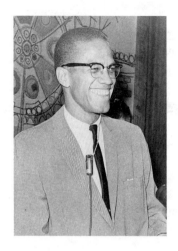

FIGURE 61. Malcolm X, 1964
*(Photo by Ed Ford; courtesy the
Library of Congress)*

Shabazz, to save the Audubon Ballroom (which had been
designated for demolition). The current owners of the
building, Columbia Presbyterian Medical Center, agreed
to restore part of the ballroom as a memorial and educa-
tional center to further Malcolm and Betty's humanitarian
work of Black self-determination and racial justice.

The center is generally open weekdays, 9 a.m. to 5 p.m.
However, the center is also rented for private events, so call
ahead to confirm it will be open prior to your visit: 212-
568-1341. Visit the website at www.theshabazzcenter.org.

*To read more about Malcolm X, see page 179. To read more
about Sugar Hill, see page 181.*

➤ This concludes Tour 5. To return to the subway (A, C, and 1 trains), walk northward on Broadway to 168th Street.

Part II

Harlem: People, Places, and Movements

Civil Rights,
Social Justice Movements,
and Overcoming the Odds

Despite Harlem's flamboyant nightlife and its many color-
ful, well-known personalities, during the 1920s and espe-
cially following the stock-market crash of 1929, the signs of
an emerging ghetto could be seen.[1] It was difficult for the
average Black person to find anything other than menial
employment in the 1920s and 1930s. A 1930s article in the
New York Herald Tribune reported that the Wall Street
stock-market collapse in 1929 "produced five times as much
unemployment in Harlem as in other parts of the city."[2]
Certainly, Blacks were hit harder economically during
the 1930s than whites were because of the persistence of
racial segregation in housing and employment. Blacks
were barred from working in all but a very small handful
of menial jobs at the shops on 125th Street (the main shop-
ping street in Harlem), even though they were overwhelm-
ingly the patrons at these same stores. It was the same story
at the city's electricity company, the telephone company,

the city-owned Independent Subway System, and many of the federal relief programs, and the same story also prevailed in most of the jobs available through the public and private sectors.[3]

A number of political and religious movements were embraced, and the successes of fellow Blacks were idealized to alleviate the pain. Churches vastly contributed to the alleviation of social ailments. From the beginning of the Harlem Renaissance, churches were social, political, and religious strongholds in the uptown Black community— roles that continue to the present day. Many churches, including Abyssinian Baptist, St. Philip's Episcopal, Bethel African Methodist Episcopal, and Mother AME Zion, migrated from downtown Manhattan and purchased churches from white congregations fleeing Harlem's increasingly Black presence, or they purchased lots and built new churches for their congregations.[4] In the 1930s, church and civic leaders led the fight against racial oppression in Harlem. Most prominently, the charismatic and brilliant Adam Clayton Powell Jr. was at the forefront of this movement. In 1931, Powell was assistant pastor to his father's (Adam Clayton Powell Sr.'s) congregation at Abyssinian Baptist Church. Between 1931 and the late 1960s, Powell Jr. led a number of successful protests aimed at breaking down racist practices in Harlem.

In March 1935, a riot broke out in Harlem when a rumor spread that a boy accused of shoplifting in a store on 125th

Street had been brutally beaten by the store's clerks. In an article published in the *New York Post* a few days after the riot, Powell argued, "It was not a riot: it was an open, unorganized protest against empty stomachs, overcrowded tenements, filthy sanitation, rotten foodstuffs, chiseling landlords and merchants, discrimination on relief, disfranchisement, and against a disinterested administration."[5] It became necessary to stage a number of protests against the shops on 125th Street, the electricity company, and the telephone company. The protests were led by Arnold Johnson, Asa Phillip Randolph, Lloyd Imes, Sufi Hamid, and Adam Clayton Powell Jr. After the companies and shops were asked and refused to hire Blacks except in menial positions, five thousand Harlemites turned out and marched. From river to river, every store on 125th Street was closed. The impact was tremendous. On August 6 and August 8, shop owners sat down with the protest leaders and made an agreement to hire Blacks.

The protests continued with the telephone company, which was put under pressure when protesters organized themselves to make thousands of synchronous phone calls, making it impossible to predict how many operators to hire or schedule at a given time. Likewise, the utility company was harassed by customers paying $30 and $40 utility bills in pennies. Protests such as these brought the telephone and electric companies to the negotiation table and opened the door for the employment of Blacks.[6]

Individual entrepreneurs devised a number of clever means to overcome poverty. Spiritualist leader Father Divine attracted a large following for his cult at 455 Lenox Avenue in the early 1930s.[7] Divine, no doubt, lacked scruples in some of his doings. For example, he did not object to his followers' belief and reference to him as the "living God," but as one of his contemporaries observed, his ministry beat the federal government's New Deal Depression relief program by a mile.[8] Like Marcus Garvey, Divine established businesses that served and were serviced by the Harlem community, and his meals surpassed any similar prior attempts to feed Harlemites. At many of his dining halls or "heavens," as they were called by his followers, you could buy a huge dinner of healthy portions and a number of selections of vegetables, meats, breads, drinks, and desserts for fifteen cents.[9]

Blacks paid considerably higher percentages of their incomes toward rent than whites did. A 1927 study by the National Urban League showed that the average monthly rent for a Black family in a four-room apartment was $55.70. The same study showed that the Black family's average annual income was about $1,300. The white equivalent was $32.43 in rent on a family income of $1,570.[10] In order for Harlemites to offset rents they could hardly afford to pay, they began holding "rent parties" with a spread of southern cooking, bootleg liquor, and live musical entertainment and dancing that lasted throughout the

night. Admission was usually fifteen to twenty-five cents. Stride-piano entertainment was a regular feature. People were attracted to the parties by clever advertisements such as these: "If sweet mama is running wild, and you are looking for a do-right-child, just come around and linger" and "Let your papa drink the whisky, let your mama drink the wine, but you come to Cora's and do the Georgia grind" (sent to Langston Hughes). This is but one example of how obstacles put before blacks, in this case high rents and low income, were at least temporarily overcome.[11]

In the 1930s, however, the numbers racket, essentially an illegal lottery, was the most prevalent moneymaker. If Negros could not gain monetary independence through legal routes, they could at least try to do so illicitly. The numbers system was established in the 1920s by a West Indian by the name of Casper Holstein. By the mid-1920s, Holstein had amassed a personal fortune and had become a community philanthropist. By 1928, his dominance in the numbers market was being eroded by the German Jewish mobster Dutch Schultz.[12] According to the political leader Malcolm X, who arrived in Harlem in the 1930s, "Hundreds of thousands of New York City Negroes, every day but Sunday, would play [the numbers] from a penny on up to large sums on three-digit numbers. . . . With the odds at six hundred to one, a penny hit won $6, a dollar won $600, and so on. On $15, the hit would mean $9,000. Famous hits like that had bought controlling interests

in lots of Harlem's bars and restaurants, or even bought them outright."[13]

By the 1930s, the Harlem numbers racket was dominated by Ellsworth "Bumpy" Johnson, a southerner who initiated his role into the Harlem racket as the leading "lieutenant" of a Black, female numbers racketeer, Stephanie St. Claire. Johnson and St. Claire's outfit set into battle over control of Harlem's turf against Dutch Schultz and the Italian mobster Lucky Luciano. St. Claire eventually "retired" from the racket, Dutch Schultz was murdered, and Johnson eventually won over the trust of the Italian mobsters, agreeing to work within their organization as the Harlem representative for four decades.

Still, many Harlemites found some relief from their economic and political woes by identifying with the successes of world heavyweight boxing champion Joe Louis. Each time Louis, who was Black, won a fight, to Blacks all over the country, it was as if he were winning battles that somehow they could not seem to win, no matter how hard they tried.

Finally, political and economic justice was addressed with Adam Clayton Powell Jr.'s entry into federal politics. In 1941, Powell became a New York City Council member, and he entered federal politics in 1945 as a U.S. congressman, eventually gaining the chairmanship of the powerful Committee of Education and Labor in 1961. Powell spoke out against racially segregated facilities on Capitol

Hill and racist language spoken by southern congressmen on the floor. He played a major role in the passage of about fifty laws in favor of working-class and under-represented Americans of all ethnic backgrounds, including an increased minimum wage and hourly work limits for employees, expanded educational funding for public schools and libraries, and equal pay for women. He also challenged southern poll taxes used against Blacks since the late nineteenth century to discourage their voting.

The 1930s Harlem
Arts Movement

The decade of the 1930s was an important era for Harlem in the development of the visual arts. The movement was largely inspired to redress negative images that proliferated through American popular culture, including minstrelsy entertainment during the nineteenth and early twentieth centuries. Consequently, artworks in the movement typically comprised scenic or sculptural re-creations of significant Black social and political movements or historically noteworthy Black individuals, reflecting realistic representations of African and African American experiences and viewpoints of life. The movement included sculptress Augusta Savage and painters Aaron Douglas, James L. Wells, Charles Alston, Jacob Lawrence. Several private and public institutions assisted in funding arts education and exhibits, including the College Art Association (CAA), the National Urban League, the Harmon and Carnegie Foundations, and the federal government's Works Progress Administration (WPA). The Harlem New York Public Library, the Harlem YMCA, and Harlem Hos-

pital provided space for exhibitions and the installation of public wall murals, some of which remain in place for viewing today.

However, in seeking funding sources that originated outside the Black community, Harlem artists came to see a need to gain control over who and what artworks merited funding. In a 1934 article in the National Urban League's journal, *Opportunity*, collage artist and painter Romare Bearden spoke for many established Harlem artists in his scathing article stating that funding from the Harmon Foundation had jeopardized the integrity of Harlem artists and distorted the image of Black subject matter. Bearden stated, "[The Harmon Foundation's] attitude from the beginning has been of a coddling and patronizing nature. It has encouraged the artist to exhibit long before he has mastered the technical equipment of his medium. By its choice of the type of work it favors, it has allowed the Negro artist to accept standards that are both artificial and corrupt."[1]

An additional grievance was the federal government's apparent refusal to appoint African Americans to supervisory positions in its WPA projects.[2] In the 1920s, Harlem artists had already established a tradition of creating art based on political, Black historical, and socially conscious themes. By the early 1930s, primarily at the 306 Art Studio—a studio converted by painter Charles Alston and sculptor Henry W. Bannarn from a former horse

stable at 306 West 141st Street—artists were meeting and holding informal discussions with writers, musicians, and intellectuals. Their discourses were reflected in their art, which was often directed toward social activism. Harlem artists established the Harlem Artists Guild to address their concerns. The guild was successful in lobbying for Charles Alston to become the first Black supervisor of a WPA arts project at Harlem Hospital. The guild's lobbying efforts also successfully fought to enable Afrocentric themes in the hospital murals. Another significant accomplishment of the guild was lobbying for the establishment of the Harlem Community Arts Center on 125th Street and Lenox Avenue.

The New Negro Movement and "Niggerati Manor"

In 1925, Alain Locke, professor of philosophy at Washington, D.C.'s Howard University, edited an anthology of essays, poems, and drawings titled *The New Negro*.[1] The book included works by a diverse group of individuals—young writers, artists, and elder statesmen, men and women, Blacks and whites, participants and spectators of the burgeoning movement centered in Harlem.

Under Locke's direction, the anthology became an unofficial call for Black artists to exemplify their humanity through the creation of art and literature. *The New Negro* and those who closely adhered to its views, that is, "New Negros," were in sync with Black intellectuals advocating to create distance between themselves and derogatory images of Blacks, prevalent in mainstream, white-dominated media and culture. There was a tendency among the "old guard" of the New Negro movement, however, to distance themselves from poor or working-class Black movements, in order to verify their humanity. For example, W. E. B. Du Bois expressed that younger Harlem artists and writers

were too busy pandering their works to please whites, who yearned to see "primitive" or "underworld" representations of Harlem.[2] Thus, everyday and working-class movements and arts were often overlooked or shunned by the New Negro "old guard." For example, Marcus Garvey's vastly popular, working-class, UNIA movement and the popular Black musical expression of the blues were often overlooked or looked down on by New Negro elders.

The subtext of the New Negro movement was challenged by younger, nonconformist, Black Harlem artists and intellectuals, who although validated as never before through publications and art exhibitions of the era, envisioned much broader and bolder self-representations. It was also likely that the younger vanguard also felt there was among the New Negro establishment a dearth of critical self-examination of the diversity and often conflicting identities among Blacks. For example, inter-Black tensions regarding differences in class or sexual orientation and oppression of women had yet to be critically examined. Taking into context the cultural milieu of the United States at the time, the New Negro movement was a daring development; however, it was not bold enough to confine the more progressive Black intellectuals and artists, several of whom were advanced far beyond the thinking of their time. It was necessary for young artists and intellectuals to create the means to express themselves on their own terms.

Shortly after the publication of *The New Negro*, Zora Neale Hurston and Wallace Thurman coined the term "Niggerati"—a combination of the terms "literati" and the derogatory "nigger"—to shockingly and humorously refer to themselves, the hustling young writers who had suddenly become vogue in the 1920s Harlem scene.[3] Thurman's apartment came to be known as "Niggerati Manor." At a time when Blacks and their culture were commonly thought of and referred to as "primitive" and the New Negro "old guard" was largely concerned with overcoming white conceptions of Blacks (rather than valorizing *all* Black art and culture), vanguard Black artists sought to express themselves free of any external expectations regardless of the source. The term "Niggerati" was created to shock and overturn the status quo, whether imposed on Blacks from establishment whites or from Blacks themselves. The chief protagonists who frequented "Niggerati Manor" were writer and editor Thurman, illustrator and writer Bruce Nugent, writer Langston Hughes, writer and social satirist Hurston, and poet Countee Cullen. Several participants of the movement were gay, including Thurman, Nugent, and possibly Hughes. One Harlemite described the "Niggerati Manor" as "decorated in red and black, with gaudy wicker furniture, [and] to reflect Thurman's sexual interests, brightly illustrated phalluses adorned the walls," painted by Nugent.[4] The protagonists of "Niggerati Manor" set examples in their works, intellectual outlook,

and humor for younger avant-garde artists and writers who frequented the apartment, including Jessie Fauset, Aaron Douglas, John P. Davis, Gwendolyn Bennett, and Dorothy West, and the apartment became a sort of "cradle of revolt" against establishment arts in Harlem.[5]

The protagonists of "Niggerati Manor" organized to publish a journal of their own, titled *Fire!*, to more boldly express the breadth and depth of Black art and culture. Thurman served as editor, and contributing authors included Hurston, who offered the script from her play *Color Struck* about Jim Crowism and internalized colorism and her short story "Sweat" on Black gender roles. Hughes's short story "Elevator Boy," Countee Cullen's poem "From the Dark Tower," Bruce Nugent's short story on gay Harlem, and Aaron Douglas's scenic illustrations of Africa were included. Unfortunately, only the first edition of *Fire!* was realized. Ironically, the majority of the copies were burned up in a fire mishap in the printer's basement, as the journal's contributors were drawn into various other projects that they hoped would actually pay the bills.[6] Nevertheless, progressive Harlem Renaissance artists and writers went on to create means to express their viewpoints and artistic creations on their own terms through various publications and art exhibits during the 1920s and '30s and well beyond the Renaissance years.[7]

Marcus Garvey and the Universal Negro Improvement Association

In 1916, a Jamaican by the name of Marcus Garvey arrived in Harlem. Garvey had traveled throughout Central America and Europe and found Blacks oppressed everywhere he went. He had been exposed to the writings of Booker T. Washington and was duly impressed. Garvey came to the United States intending to raise funds to return to Jamaica to establish an institution modeled after Booker T. Washington's Tuskegee Institute. Upon arrival, Garvey found that Washington had recently passed away. Nevertheless, Garvey forged ahead with a plan of his own. He created the Universal Negro Improvement Association (UNIA) to promote self-help, racial pride, and a back-to-Africa movement to the Black masses. UNIA headquarters were located at 38 West 135th Street between Sixth and Fifth Avenues. By the early 1920s, Garvey had become the most charismatic political leader in Black America. His promotion of Black pride appealed to thousands of common

Blacks who found little acceptance or found it difficult to identify with highly educated Black leaders such as intellectuals within the NAACP.[1] At the same time, some formally educated Blacks, such as writer Claude McKay, embraced Garvey's movement because of the positive image of Blackness promoted and because of his impressive ability to raise capital and people power. For example, Garvey raised enough money to establish an all-Back shipping company for his back-to-Africa effort, and in 1920, he held an international convention at Madison Square Garden with twenty-five thousand Blacks in attendance.

As the movement grew, the UNIA established an unprecedented number of offices and shops run and owned by Blacks throughout Harlem. Despite the amount of organization that Garvey was able to achieve, he was facing powerful opposition from outside the UNIA. Garvey espoused the belief that separation between the races was the best solution to racial strife. As he openly pursued goals in accordance with his belief, he ran into stern objections from conservative Blacks such as those within the NAACP, who advocated for racial integration. At the same time, many whites were threatened by Garvey's impressive organizational abilities. Soon, the forces against him became insurmountable, and in 1927, the FBI, with the support of some Black leaders, maneuvered his deportation as an illegal alien.[2]

Vaudeville Theater
and Minstrelsy

There were two forms of popular Black entertainment featured at the turn of the twentieth century that comprised theatrical and musical entertainers. Theatrical entertainers performed vaudeville skits using song, dance, acting, and comedy. The second group was made up of prejazz musicians who played in rhythmically syncopated orchestras that drew repertoire from Black folksongs combined with Western harmonic and structural forms. Because Blacks were excluded from white musician and theater unions, it became necessary for them to establish their own organizations to seek work, to bargain for fairer performance fees, and to promote their talent on their own terms. Three leading Harlem clubs representing entertainers were The Frogs club, a theatrical organization that was located at 111 West 132nd Street; the Tempo Club, a musicians union formed in 1913 at 138 West 136th Street; and the New Amsterdam Musical Association (NAMA), incorporated in 1905. NAMA's long-established home from 1922 to the present is located at 107 West 130th Street. All three

organizations comprised many of the most successful Black musicians, actors, and comedians of their day.

At the helm of the musicians' organizations was orchestra leader James Reese Europe, founder of the Tempo Club, who directed large orchestras of one-hundred-plus men including pianists, percussionists, and banjo and mandolin players. Europe was also a member of the New Amsterdam Musical Association along with other noted musicians Eubie Blake and Fletcher Henderson.[1]

Europe had established his reputation in midtown Manhattan at the Clef Club, the name of his booking agency and the headquarters and name of his own orchestra. As the leading orchestra in New York, the Clef Club orchestra employed Black musicians for dances and parties held by such elite, white families as the Astors and Vanderbilts. In 1913, Europe moved his operation uptown to Harlem and established the Tempo Club, where he continued the functions of presenting dances and concerts for Black audiences and booking Black orchestras to play at large white dance halls throughout the New York metropolitan area.

Another popular social club at the time comprising Black entertainers and writers was The Frogs club. While all the members of The Frogs club were successful in their own right, the comedic theatrical team of Bert Williams and George Walker perhaps best illustrated a conundrum facing Black entertainers of the era. The duo came of age during the height of minstrel entertainment in the late

nineteenth century, when initially white actors painted their faces black and performed stereotypical characterizations of shuffling, ignorant Blacks. With far too few paying performance options open to Black theatrical performers at the time, in an ironic twist, Black minstrel entertainers emerged in the later half of the century. It was Williams and Walker's intervention into minstrelsy, however, that brilliantly transformed a performance of racial stereotypes into a luminous and hilarious performance of art. The duo performed human trials and tribulations that people of any "race" could find humor in. As stated by George Walker, the team intervened by presenting "authentic" renditions of Black performance and, by doing so, made the white performance of Blacks obsolete. Walker states,

> Nothing about these white men's actions was natural, and therefore nothing was as interesting as if black performers had been dancing and singing their own songs in their own way. . . . We thought that as there seemed to be a great demand for black faces on the stage, we would do all we could to get what we felt belonged to us by the laws of nature. As white men with black faces were billing themselves "coons," Williams and Walker would do well to bill themselves the "Two Real Coons," and so we did.[2]

Williams and Walker centered their performance on a routine in which Walker played the quick-witted hustler, always out to make a fast buck, and Williams performed

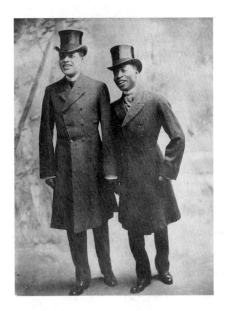

FIGURE 62. Bert Williams and George Walker, 1900s *(Photographs and Prints Division, Schomburg Center for Research in Black Culture, The New York Public Library)*

a downtrodden buffoon, for whom nothing ever worked out quite right. Their performance of the cakewalk became an international sensation. While Walker proved the most skilled cakewalker, Williams demonstrated a comically brilliant, laidback pantomime in body and voice that mesmerized his audiences. The duo had a profound impact on Black theatrical entertainment in Harlem showcases in the early twentieth century.[3]

The Development of Bebop (Jazz) in Harlem

In the mid-1930s, the music of bebop began to surface in Harlem. Bebop musicians often originated in the larger swing-band orchestras that were arranged for popular dances. However, the musicians were looking to expand themselves musically from having to play the same arrangements night after night, as done in swing bands, and they added a complex of altered harmonic changes, typically fast tempos, and extended melodic improvisations to their own compositions or the songs traditionally performed in swing bands. There was a political component to bebop too that voiced a concern that consumers of the highly popular swing-band music did not recognize Black music as high art. Bebop musicians wanted their audiences to sit down and appreciate their music intellectually as well as enjoy it aurally.

Experimentations with bebop were taking place around 1934 at Monroe's Uptown House. Clark Monroe took over the old Barron's Exclusive Club site and ran a late-night bebop session there until 1943. Minton's Playhouse

opened in 1940 and began featuring bebop. In the words of Miles Davis, "the musicians and the people who really loved and respected bebop and the truth know that the *real* thing happened up in Harlem, at Minton's."[1] Pianist Mary Lou Williams's apartment at 21 Hamilton Terrace also was frequented as an informal bebop school, especially for piano players.

Speakeasies, Small Clubs, Jungle Alley, and Stride Piano Players

During the Prohibition era (1920–1933), speakeasies played a tremendous role in keeping entertainment alive in Harlem. While the sale and distribution of alcohol was legally prohibited throughout the United States, alcohol consumption moved underground into illegal speakeasies. For Harlem's struggling inhabitants, opening a speakeasy in a basement or a back room of a legitimate business or residence was a way out of poverty, and a reported estimate of six hundred speakeasies spread throughout the community.[1] Speakeasies could be found on just about every block of Harlem; however, they were particularly abundant on or in close vicinity to 133rd Street between Adam Clayton Powell Jr. Boulevard and Lenox Avenue, a block known at the time as "Jungle Alley." Billie Holiday recalled Jungle Alley having around twelve after-hours music and eating spots.[2]

A common and extraordinarily popular style of piano playing found at most all the speakeasies was Harlem

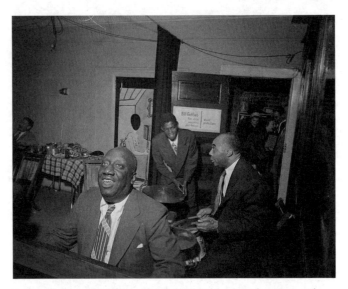

FIGURE 63. James P. Johnson, facing the camera, plays the piano with his band at a house party in Jamaica, Queens, NY, ca. 1948 (*William P. Gottlieb / Ira and Leonore S. Gershwin Fund Collection, Music Division, Library of Congress*)

stride piano. Stride piano was a unique Harlem development that bridged the gap between formalized, that is, scored, ragtime and jazz improvisation. It has been described as "a strong 'walking bass' in the left hand as the right performed chords and arpeggios in counter rhythms. There was always the attempt, on the part of keyboard artists to improve upon known melodies and the other man's technique."[3] The leaders of stride development were James P. Johnson, Eubie Blake, Luckey Roberts, and Willie "The Lion" Smith. Other contributors included Thomas

"Fats" Waller, Stephen "The Beetle" Henderson, Leroy Tibbs, Alberta Simmons, Willie Gant, and Raymond "Lippy" Boyette. The stride players were extraordinarily colorful performers who perfected their musicianship through constant practice and respectful but fierce musical battles or competitions played out between the piano players in local Harlem venues. Their highly advanced level of musicianship made them a major attraction to younger jazz musicians such as Duke Ellington and Art Tatum. The stride players were equally popular as accompanists for cabaret singers in Harlem bars and speakeasies and at house "rent parties" devised to offset extraordinarily high rents and low income for Harlemites. For more on rent parties, see "Civil Rights, Social Justice Movements, and Overcoming the Odds," on page 151.

Stride pianist Willie "The Lion" Smith recalled what one would typically find on Jungle Alley:

> It must have been the busiest street in the world. There were fourteen different [speakeasies], at least. In that one block you had The Nest, Mel Frazier's small club where Luis Russell had the band; Tillie's Chicken Shack with Bob Howard playing the piano; an after-hours spot run by a three-hundred-pound character named Basement Brown and his pal "Gulfport" (you had to knock three times and blow your nose to get inside; during Prohibition, every place had its passwords and signals) both ex-vaudevillian opium smokers; Mexico's, run by a fellow named Gomez who was from one

of the Carolinas and had never seen Mexico; Harry Hansberry's The Clam House where Gladys Bentley sang songs with lyrics like her famous "My Subway Man" that couldn't be sent through the mails; and a short block further uptown the first Rhythm Club was located in the basement of the building next door to the Lafayette Theater.[4]

James Baldwin, Richard Wright, and Ralph Ellison

Three Harlem writers of great importance prospered near the end or after the 1930s, the second decade of the Harlem Renaissance. James Baldwin was born at Harlem Hospital in 1924. It was in Harlem that Baldwin developed his views on racism (he was beaten by three police officers while young) and acquired an avid interest in literature. By the age of fourteen, he was spending hours each day in Harlem public libraries reading through countless books. As a young man, he announced his homosexuality and began writing fiery essays and books expressing his powerful views and contempt for racism and homophobia. Baldwin joined ranks with civil rights leaders during the 1960s, speaking out across the United States. He is rightfully acknowledged as one of the most forceful American writers of the twentieth century. Baldwin attended school at Public School 24 (now Harlem Renaissance High School) on East 128th Street between Fifth and Madison Avenues in Harlem, and in 2014, the street was renamed in his honor.

The writing careers of Richard Wright and Ralph Ellison in some ways mirror each other. Wright and Ellison migrated to Harlem in the late 1930s and began working for the Works Progress Administration (WPA). Wright contributed an essay on Harlem for the WPA's *New York Panorama* guidebook in 1938. Ellison recorded children's word games at the playground at Lenox Avenue and West 135th Street for the WPA. Both Wright and Ellison wrote highly acclaimed novels on the racial struggles of Black men. Wright published the first best-seller by a Black man, *Native Son*, in 1940. Ellison published his best-seller, *Invisible Man*, in 1952. A fifteen-foot bronze monument to Ellison, created by Harlem Renaissance artist Elizabeth Catlett, was installed at West 150th Street and Riverside Drive in 2003.

Malcolm X

The political ideology of Malcolm X originated in childhood when his midwestern family was fractured through a series of racially motivated and personal tragedies. These included the early death of Malcolm's father in a freakish subway calamity, which some people thought to have been a politically motivated attack, and his mother suffering from a nervous breakdown, leading to her being committed to the Michigan State mental hospital in Kalamazoo. As a teenager, Malcolm found his way to New York City, where he was employed in Harlem as a waiter at Smalls Paradise and Jimmy's Chicken Shack. It was at this time of his life, however, that he also fell into a life of petty crime, and at the age of twenty, he was sentenced to prison, serving seven years behind bars. While in prison, he discovered the teachings of Elijah Muhammad, the leader of the Nation of Islam (NOI), a Black Muslim organization that promoted an ideology of Black racial superiority and the ideal of separation between the races. Following NOI protocol, Malcolm changed his family name from "Little" to "X" to denounce the name forced on his enslaved ancestors.

After Malcolm's release from prison, he proved himself to be a loyal and effective NOI minister, and he was appointed chief minister at Temple No. 7 on 116th Street and Lenox Avenue (now Malcolm X Boulevard) in Harlem. As a powerful orator, Malcolm eventually surpassed Elijah Muhammad. But in time, he also discovered corruption in the NOI and with Elijah Muhammad himself, and a rupture between Malcolm and the NOI occurred. In 1964, Malcolm traveled to Mecca, the Islamic holy land, where he had a reawakening, leading him to see Muslims of all colors and ethnicities as one people united through Islam, while he continued to denounce racism at home and abroad. Following this development, he left the NOI and initiated a new organization, the Organization of Afro-American Unity (OAAU), based on his renewed insights on race and social justice. However, Malcolm's NOI denouncement earned him the wrath of Elijah Muhammad and his followers, and Malcolm was shot and killed by a member of the NOI while delivering a speech in 1965 at an OAAU rally at the Audubon Ballroom in upper Manhattan.

Sugar Hill

Located between 145th and 155th Streets and roughly be-
tween Edgecombe and Amsterdam Avenues to the east
and west, the neighborhood of Sugar Hill began attracting
middle-class African American residents in the late 1920s.
Similar to Striver's Row on 138th and 139th Streets, the
Hill attracted well-known personalities in the visual and
musical arts, writers, and political activists. An attraction
of the Hill has been its prominent architectural gems: Vic-
torian estates and row houses originally built in the 1700s
and 1800s to house New York's well-to-do white establish-
ment. The Hill's African American renaissance reached its
zenith in the 1930s. By the 1940s, the neighborhood was
experiencing a downward turn due to the encroachment
of illegal drug distribution and an overabundance of night-
clubs and bars, which attracted various illicit activities.[1]

During the 1940s, the neighborhood remained an excit-
ing place to live for artists and intellectuals, who lived side
by side as neighbors. Saxophone maestro Sonny Rollins
came of age on the Hill alongside other aspiring bebop
musicians Jackie McLean, Kenny Drew, and Art Taylor, all
of whom became renowned, international jazz musicians

as adults. Younger musicians were inspired by older, established musicians living on the Hill, such as Duke Ellington and others. Rollins recalled,

> [Bebop pianist] Bud Powell lived not too far from us. . . . Sugar Hill at that time was sort of the place where most of the black artists . . . who were able to . . . lived. It was sort of the nicest part. So Duke Ellington actually lived on our block. This was when I was really a kid. . . . [Big band leader] Andy Kirk lived there. Coleman Hawkins lived around the corner. We used to see guys like Sid Catlett, John Kirby, all of these guys we saw every day almost, because they all lived in the neighborhood. So it was a beautiful place to grow up. Because we all wanted to be musicians.[2]

Young musicians also rubbed shoulders with aspiring artists of other genres. As a high school student, multi-material artist and author Faith Ringgold recalled knowing Sonny Rollins when they were teenagers.[3] Residential buildings at 409 and 555 Edgecombe Avenue attracted famous, middle-class Harlemites who hosted soirees and tea gatherings every week. With New York City's A train stopping in the middle of Sugar Hill, bandleader Duke Ellington and composer Billy Strayhorn immortalized the neighborhood with Strayhorn's composition "Take the 'A' Train."

Acknowledgments

I'd like to thank Albert Taborn, Allana Radecki, and Marie Brown for reading my manuscript early on and providing me with useful feedback. The librarians at the Schomburg Center and the Library of Congress were invaluable to me in my research: in particular, the managers and assistants of the photographic archives were helpful for navigating unfamiliar and often confusing copyright law. I am profoundly appreciative of Rutgers University Press for seeing the value in this project and partnering me with my project manager, Peter Mickulas; map maker, Michael Siegel; and copyeditor, Andrew Katz. Finally, my greatest appreciation must go to the conveyors and promoters of Harlem culture in the past and the present. It is on your shoulders that the proud legacy of Harlem was built and continues into the future; to you, we are eternally grateful.

Notes

Introduction

1. *I Remember Harlem*, dir. William Miles (Films for the Humanities, 1981), film.
2. Frank Driggs, liner notes to *The Sound of Harlem*, Jazz Archives Series, Columbia Records C3L-33, 1964, 3. Also see Gilbert Osofsky, *Harlem: The Making of a Ghetto* (New York: Harper and Row, 1968), 90–104.
3. Osofsky, *Harlem*, 98.
4. Lerone Bennett, *Before the Mayflower: A History of Black America* (Chicago: Johnson, 1962), 344.
5. Jervis Anderson, *This Was Harlem* (New York: McGraw-Hill, 1982), 348.

Tour 1. Central Harlem: North

1. Paula Giddings, *When and Where I Enter: The Impact of Black Women on Race and Sex in America* (New York: William Morrow, 1984), 187–189; David Levering Lewis, *When Harlem Was in Vogue* (New York: Knopf, 1981), 110, 167.
2. Valerie Boyd, *Wrapped in Rainbows* (New York: Scribner, 2003), 129.
3. Ibid., 121.
4. Patricia Hills, *Painting Harlem Modern: The Art of Jacob Lawrence* (Berkeley: University of California Press, 2009), 27.

5. Landmarks Preservation Commission, "Mother Methodist Episcopal Zion Church," July 13, 1993, http://www .neighborhoodpreservationcenter.org/db/bb_files/Mother -African-Methodist-Episcopal-Zion-Church.pdf.

6. James W. Johnson, *Black Manhattan* (New York: Knopf, 1930), 255.

7. "Cell Ears," *Amsterdam News*, January 9, 1943.

8. Edward (Duke) Ellington, *Music Is My Mistress* (Garden City, NY: Doubleday, 1973), 49.

9. Additional residents of note on Striver's Row include P. M. Murray, dean and professor of surgery at Howard University (1917–1918), at 200 West 138th Street. Mr. and Mrs. James Kinloch of 246 West 138th Street were known for boarding musicians. The widow of ragtime master Scott Joplin lived at the Kinloch home for about six years, and postminstrel per-former Lincoln Perry, better known as "Stepin Fetchit," also frequently stayed at the Kinloch home. Noble Sissle lived at 264 West 139th Street. Sissle was the musical partner of Eubie Blake, and the two collaborated on the music for the 1921 Broadway hit *Shuffle Along*, which Langston Hughes credited for luring him to Harlem and (according to Hughes) launch-ing the Harlem Renaissance. Sissle was also a prominent musician in James Reese Europe's 369th Regiment as a singer and drummer. William Pickens, dean and vice president of Morgan College, in Baltimore, Maryland, and associate field secretary of the NAACP, lived at 260 West 139th Street. L. T. Wright, surgical director of Harlem Hospital from 1938 to 1952, lived at 218 West 139th Street. And Flournoy Miller, who was a star actor in the Broadway hit *Shuffle Along*, lived at 200 West 138th Street. Landmarks Preservation Commission, *St. Nicholas Historic District, Borough of Manhattan*, March 16,

1967, no. 2, LP-0322, 2; New York City Housing and Development Administration, *St. Nicholas Historic District* (New York: New York City Housing and Development Administration, 1973); Sonya Vann, "The Early Harlem Musical Scene, from a 100-Year-Old's Perspective," *New York Times*, September 8, 1988; "Leon Gross, Ace Saxophonist Dies," *New York Amsterdam News*, October 9, 1943, 19; Eileen Southern, *The Biographical Dictionary of Afro American and African Musicians* (Westport, CT: Greenwood, 1982), 165–166, 176, 356.

10. Frank Driggs, liner notes to *The Sound of Harlem*, Jazz Archives Series, Columbia Records, C3L-33, 1964, 32; Jervis Anderson, *This Was Harlem* (New York: McGraw-Hill, 1982), 307–314.

Tour 2. Central Harlem: Middle

1. David Levering Lewis, *When Harlem Was in Vogue* (New York: Knopf, 1981), 34–35, 109–110.
2. Patricia Hills, *Painting Harlem Modern: The Art of Jacob Lawrence* (Berkeley: University of California Press, 2009), 27; Robin Pogrebin, "At Harlem Hospital, Murals Get a New Life," *New York Times*, September 16, 2012.
3. "Sweet Spot for Harlem's Bigs," *New York Post*, July 21, 2008.
4. Lewis, *When Harlem Was in Vogue*, 81, 105. Also see Booker Thelma Berlack, "Growing Pains: Larger Quarters Needed for 135th Street Library," *New York Amsterdam News*, April 18, 1936, 13.
5. Jervis Anderson, *This Was Harlem* (New York: McGraw-Hill, 1982), 275; Lewis, *When Harlem Was in Vogue*, 104.
6. Arnold Rampersad, *The Life of Langston Hughes* (New York: Oxford University Press, 1986), 63.

7. Rex Stewart, *Boy Meets Horn* (Ann Arbor: University of Michigan Press, 1991), 81. Also see *Inter-State Tattler*, October 19, 1928.

8. Malcolm X, *The Autobiography of Malcolm X* (New York: Grove, 1965), 109–135.

9. Frank Driggs, liner notes to *The Sound of Harlem*, Jazz Archives Series, Columbia Records C3L-33, 1964, 28.

10. Ibid., 24.

11. Duke Ellington, *Music Is My Mistress* (Garden City, NY: Doubleday, 1973), 64.

12. The address listings I include for Jungle Alley have primarily been drawn from the early African American press, including the *Inter-State Tattler*, the *Amsterdam News*, and the *New York Age*. Due to speakeasies' discrete nature, they did not formerly advertise in the press, but some locations are identifiable through published police raids. In some cases, however, there are discrepancies. For example, Frank Driggs in his liner notes to *The Sound of Harlem* lists Mexico's as formerly located at 140 West 133rd Street (the address I site in this text). The same venue is recorded to have been located at 154 West 133rd Street in David Freeland's book *Automats, Taxi Dances, and Vaudeville: Excavating Manhattan's Lost Places of Leisure* (New York: NYU Press, 2009). Stories of being on the Alley I have largely drawn from autobiographies of musicians who were present there during the late 1920s to early 1930s, including Willie "The Lion" Smith's *Music on My Mind* (New York: Doubleday, 1978), Rex Stewart's *Boy Meets Horn* (Ann Arbor: University of Michigan Press, 1993), and Billie Holiday's *Lady Sings the Blues* (New York: Lancer Books, 1965). I also draw from stories published in Driggs's liner notes to *The Sound of Harlem*; and in Freeland's *Automats, Taxi Dances, and Vaudeville*, chap. 8.

13. Driggs, liner notes to *The Sound of Harlem*, 31.

14. Holiday, *Lady Sings the Blues*, 33.

15. Ibid., 34.

16. Ted Fox, *Showtime at the Apollo* (New York: Holt, Rinehart and Winston, 1983), 87.

17. Smith, *Music on My Mind*, 158–59.

18. Driggs, liner notes to *The Sound of Harlem*, 33.

19. Ellington, *Music Is My Mistress*, 92–93.

20. Frank Cullen, *Vaudeville, Old and New: An Encyclopedia of Variety Performers in America* (New York: Routledge, 2007), 421.

21. George Palmer, "Tavern Topics," *Amsterdam News*, February 13, 1958, 13.

22. George Palmer, "Topics: Around Our Town," *Amsterdam News*, March 8, 1958, 13.

23. Stewart, *Boy Meets Horn*, 81.

24. Fox, *Showtime at the Apollo*, 55.

25. James W. Johnson, *Black Manhattan* (New York: Knopf, 1930), 170–179. Also see *I Remember Harlem*, dir. William Miles (Films for the Humanities, 1981), film, part 1.

Tour 3. Central Harlem: South

1. Ted Fox, *Showtime at the Apollo* (New York: Holt, Rinehart and Winston, 1983), 104–131.

2. Ibid., 55; Jervis Anderson, *This Was Harlem* (New York: McGraw-Hill, 1982), 110; "Flo Mills 'Blackbirds' Fly," *Afro American*, April 10, 1926; "America's Leading Dancer," *Amsterdam News*, May 19, 1926.

3. Gwendolyn Bennett, "The Harlem Community Art Center," in *Art for the Millions: Essays from the 1930s by Artists and*

Administrators of the WPA Federal Art Project, ed. Francis V. O'Connor (Boston: New York Graphic Society, 1973), 213.

4. "National Negro Business League," *Afro American*, July 22, 1905, 5; Barnet Dodson, "Emancipation Exposition," *Afro American*, November 8, 1913, 7.

5. Billy Shannon, "East Harlem Brownstone That Was Home to Renowned Poet Langston Hughes Is Up for Sale," *Daily News*, November 2, 2011.

6. Landmarks Preservation Commission, "Mount Morris Park Extension Approved as a New York City Historic District," http://www.nyc.gov/html/lpc/downloads/pdf/press/2015/092215-mount-morris-park-extension-approved.pdf.

7. Miles Davis, *Miles: The Autobiography* (New York: Touchstone, 1989), 53–54.

8. Valerie Boyd, *Wrapped in Rainbows* (New York: Scribner, 2003), 269.

9. David W. Dunlap, *From Abyssinian to Zion* (New York: Columbia University Press, 2004), 136–137.

Tour 4. West Harlem: North

1. Whitney Balliet, *American Musicians* (New York: Oxford University Press, 1986), 102.

Tour 5. West Harlem, Washington Heights: Far North

1. Alan Oser, "Perspectives: The Dunbar Apartments," *New York Times*, January 21, 1990. Also see T.E.B., "Chatter and Times," *Amsterdam News*, October 14, 1939, 16.

2. "Big Opening of Swank Poosepahtuck Club," *Amsterdam News*, October 19, 1935, 7. Also see "Sugar Hill Is Disturbed by

Music Grinder," *Amsterdam News*, April 16, 1938; "Club Chats," *Amsterdam News*, June 16, 1934, 4; "Hectic Harlem," *Amsterdam News*, August 24, 1935, 11.

3. "Mrs. Sissles's $2,500 Coat Returned," *Amsterdam News*, April 10, 1929; "Chatter and Chimes: Thurgood Marshalls Are Hosts," *Amsterdam News*, May 13, 1939; "Luncefords Are Host at Party," *Amsterdam News*, April 4, 1936; "Society," *Amsterdam News*, November 13, 1937; "Gather at Douglases," *Amsterdam News*, July 16, 1938; *New York Age*, January 13, 1940, 4; "Tenants Picket 409 Edgecombe," *New News*, May 21, 1938, 11; "Society," *Amsterdam News*, April 30, 1930; "N.Y. Number Queen Accuses Cops of Graft . . . ," *Philadelphia Tribune*, December 18, 1930; *People's Voice*, November 18, 1944.

4. "La Fiesta Mexicana," *Amsterdam News*, April 16, 1938, 8; "Gather at Douglases."

5. Jervis Anderson, *This Was Harlem* (New York: McGraw-Hill, 1982), 340–345.

6. "Chatter and Chimes: Robesons Engage Apartments," *Amsterdam News*, October 28, 1939; "Relatives of Ring Champ Arrive for Fight," *New York Age*, June 21, 1941; "Back Door Stuff," *Amsterdam News*, June 3, 1944; "Amusement Row," *Amsterdam News*, December 4, 1948; "Canada Lee to Wed Wini Johnson," *Amsterdam News*, April 29, 1944; "Mrs. Kirk Entertains Members of Sorority," *Amsterdam News*, October 21, 1944; *People's Voice*, January 2, 1943; *People's Voice*, December 18, 1943; "Joe Louis' Marriage Headed for Rocks," *People's Voice*, December 20, 1947; *New York Age*, October 9, 1948; *New York Age*, October 27, 1945; "Mrs. Robeson Hostess to Her Bridge Club Members," *New York Age*, February 1, 1941; Deloris Calvin, "Benny Decides to Travel by Train," *Atlanta Daily World*, July 27, 1942; William "Count" Basie, *Good Morning Blues* (Cambridge, MA:

Da Capo, 1985), 215; "Relatives of Ring Champ Arrive for Fight," *The Fight City*, http://www.thefightcity.com/joe-louis-vs-billy-conn/. Note: although Lena Horne's biography does not mention 555 Edgecombe Avenue, there is considerable hearsay that she also once resided here while visiting Joe Louis.

7. "Streetscapes: Sylvan Terrace; Restoration Leaves a Lot of Unhappy Homeowners, *New York Times*, April 9, 1989.

Civil Rights, Social Justice Movements, and Overcoming the Odds

1. David Levering Lewis, *When Harlem Was in Vogue* (New York: Knopf, 1981), 240.
2. Jervis Anderson, *This Was Harlem* (New York: McGraw-Hill, 1982), 242.
3. Gordon Parks, *Voices in the Mirror* (New York: Doubleday, 1990), 52–53. Also see *I Remember Harlem*, dir. William Miles (Films for the Humanities, 1981), film.
4. Gilbert Osofsky, *Harlem: The Making of a Ghetto* (New York: Harper and Row, 1968), 113–117.
5. "Powell Says Men Can't Get Jobs," *New York Post*, March 27, 1935.
6. *I Remember Harlem*, part 3.
7. Lewis, *When Harlem Was in Vogue*, 224.
8. Anderson, *This Was Harlem*, 253.
9. Ibid., 252.
10. Lewis, *When Harlem Was in Vogue*, 108. This predicament was able to persist because much property continued to be owned and controlled by those who no longer resided in the community and whose foremost interest was in earning a profit rather than contributing to a stable Harlem community.

11. Ibid.,107.
12. Ibid., 220–221.
13. Malcolm X, *The Autobiography of Malcolm X* (New York: Grove, 1965), 85.

The 1930s Harlem Arts Movement

1. Patricia Hills, *Painting Harlem Modern: The Art of Jacob Lawrence* (Berkeley: University of California Press, 2009), 26.
2. Ibid., 27.

The New Negro Movement and "Niggerati Manor"

1. Alain Locke, *The New Negro* (New York: Touchstone, 1925).
2. W. E. B. Du Bois, "Criteria for Negro Art," *Crisis* 32 (October 1926): 290–297; David Levering Lewis, *When Harlem Was in Vogue* (New York: Vintage, 1982), 176–177.
3. Valerie Boyd, *Wrapped in Rainbows* (New York: Scribner, 2003), 121.
4. Ibid., 121–122.
5. Lewis, *When Harlem Was in Vogue*, 40–45.
6. Ibid., 194–197.
7. See, for example, Langston Hughes's later essays on the character of Semple, first published in 1943, were a critique on inter-Black class relations. Also see Hughes's poems and essays on the blues in various publications. Zora Neale Hurston is noteworthy for her important contribution of collecting southern folklore. Although folklore had been collected and examined previously, Hurston importantly added cultural context in her renditions of folklore. Hurston is also noteworthy for including her experiences and observations on male-female

gender distinctions among Blacks and for exemplifying female empowerment in her fictional characters and her personal life choices. For example, see Boyd, *Wrapped in Rainbows*. Bruce Nugent's openly gay storytelling was rare at the time of the Harlem Renaissance and during this period of American and African American history.

Marcus Garvey and the Universal Negro Improvement Association

1. Bruce Kellner, *The Harlem Renaissance: A Historic Dictionary of the Era* (Westport, CT: Greenwood, 1984), 133.
2. Schomburg Center for Research in Black Culture, "Marcus Garvey Movement in Harlem: Walking Tour," 1987; David Levering Lewis, *When Harlem Was in Vogue* (New York: Vintage, 1982), 40–45; Edmund David Cronon, *Black Moses: The Story of Marcus Garvey and the United Negro Improvement Association* (Madison: University of Wisconsin Press, 1969), 49–50.

Vaudeville Theater and Minstrelsy

1. Reid Badger, *A Life in Ragtime: A Biography of James Reese Europe* (New York: Oxford University Press, 1995). 36–37, 97.
2. Quoted in Jervis Anderson, *This Was Harlem* (New York: McGraw-Hill, 1982), 36–37.
3. David Levering Lewis, *When Harlem Was in Vogue* (New York: Vintage, 1982), 30–34; Badger, *Life in Ragtime*, 36–37, 97.

The Development of Bebop (Jazz) in Harlem

1. Miles Davis, *Miles: The Autobiography* (New York: Touchstone, 1989), 55.

Speakeasies, Small Clubs, Jungle Alley, and Stride Piano Players

1. "Seabury Graft Quiz to Hit 600 Harlem Speakeasies," *Atlanta World*, December 23, 1931.
2. Billie Holiday, *Lady Sings the Blues* (New York: Lancer Books, 1965), 33.
3. Frank Driggs, liner notes to *The Sound of Harlem*, Jazz Archives Series, Columbia Records C3L-33, 1964, 7.
4. Willie "The Lion" Smith, *Music on My Mind* (New York: Da Capo, 1978), 158–159.

Sugar Hill

1. "Once Exclusive Sugar Hill Fading," *Amsterdam News*, July 22, 1939. Also see Jackie McLean's comments in A. B. Spellman, *Four Lives in the Bebop Business* (New York: Pantheon Books, 1966), 193.
2. Ben Sidran, *Talking Jazz: An Oral History* (New York: Da Capo, 1995), 171–172.
3. Faith Ringgold, *We Flew over the Bridge: The Memoirs of Faith Ringgold* (Boston: Little, Brown, 1995).

Index

About the Author

Karen F. Taborn moved to Harlem, New York, in the early 1980s and has lived in the neighborhood for over thirty years. From 1991 to 1994, she served as the historical and cultural consultant for the Strivers Center Project—a landscape and cultural revitalization project in Central Harlem that culminated in the Harlem Walk of Fame on West 135th Street between Frederick Douglass and Adam Clayton Powell Jr. Boulevards (Seventh and Eighth Avenues; see Tour 2, Site 8, in this book). Taborn holds master of arts degrees in jazz from New York University (1988) and ethnomusicology from Hunter College (2006). Taborn has taught courses on Harlem history at the New School for Social Research (aka the New School University) and "Understanding Cultural Diversity" and "The Arts in New York City" at the City University of New York (CUNY) at York College and Guttman College. Follow her and her various works by visiting her website at https://karentabornwalkingharlem.wordpress.com.

Further Reading about Harlem
Published by the Rutgers University Press

Literary

The Collected Writings of Wallace Thurman:
A Harlem Renaissance Reader
Edited by Amritjit Singh and Daniel M. Scott III

Double-Take: A Revisionist Harlem Renaissance Anthology
Edited by Venetria K. Patton and Maureen Honey

A Long Way from Home
Claude McKay, edited by Gene Andrew Jarrett

Quicksand and Passing
Nella Larson, edited by Deborah E. McDowell

Shadowed Dreams: Women's Poetry of the Harlem Renaissance
Edited by Maureen Honey

The Sleeper Wakes: Harlem Renaissance Stories by Women
Edited by Marcy Knopf-Newman

"Sweat"
Zora Neale Hurston, edited by Cheryl A. Wall

Zora Neale Hurston: Collected Plays
Edited by Jean Lee Cole and Charles Mitchell

Nonfiction

Aphrodite's Daughters: Three Modernist Poets of the Harlem Renaissance
Maureen Honey

Jean Toomer and the Harlem Renaissance
Edited by Geneviève Fabre and Michel Feith

Literary Sisters: Dorothy West and Her Circle, A Biography of the Harlem Renaissance
Verner D. Mitchell and Cynthia Davis

Making a Promised Land: Harlem in Twentieth-Century Photography and Film
Paula J. Massood

Portraits of the New Negro Woman: Visual and Literary Culture in the Harlem Renaissance
Cherene Sherrard-Johnson

The Shadowed Country: Claude McKay and the Romance of the Victorians
Josh Gosciak